on physics

First published in the United Kingdom in 2004 by
Dewi Lewis Publishing
8, Broomfield Road
Heaton Moor
Stockport SK4 4ND
England

wwww.dewilewispublishing.com

For the photographs and artwork: © 2004 Naglaa Walker
For the texts: 'Physical Moment' © 2004 Sacha Craddock;
'Physics as Metaphor' © 2004 Dr. John Gribbin (revised from an essay
originally published in *Schrödinger's Kittens*, published by Phoenix)
For this edition: © 2004 Dewi Lewis Publishing

Excerpts from pages 3, 12, 49, 328, 335 and 493 of *Chaos and Nonlinear
Dynamics: Introduction for Scientists* (2000) by Robert C. Hilborn are
reproduced, and in some cases amended by Naglaa Walker, with the
kind permission of the author, and of Oxford University Press.

Designed by Dewi Lewis and Naglaa Walker
Printed in Italy by EBS Verona

naglaa walker on physics

with texts by **sacha craddock & john gribbin**

dewi lewis publishing

sacha craddock: physical moment

Naglaa Walker's work 'On Physics' seems to make notion, language, method and genre flow in the same direction. From the start, this series suggests a good deal of complex reasoning and questioning. Walker gives the work a tone that implies that interpretation is exactly what it is all about and yet there is still something going on that cannot be fully understood. A sort of chaos emerges, from out of a sub-titled world which brings disparate elements to the same artistic place, and this seems to interfere with the very structures of perception.

The fiction of the photographs inevitably lies in many different places but the fact is also extremely illusive. Walker expands the role of the reporter as photographer as well as constructor of illustrative sub-text. The more realist the 'look'; the more dead pan and plausible the photographic construction in park, flat, street, or holiday destination, the stronger the role that the strap line, representing or translating the physics, needs to play. Though written by Walker these titles appear as a universal, unquestionable truth that functions as more than just a translation for people who don't understand science. But she maintains that their addition is able to extend rather than narrow conceptual space; that a crowded room does not necessarily always appear smaller.

The explanation is just about adequate, she says. She studied physics herself, but still none of this is fixed or final. The belief that something can be exact in a totally inexact world is perhaps one of few reasons to test art and science together in the same context. Text next to image or text next to image of text or diagram is all a well-worn method for setting up artistic possibilities. Modernism, in part, brought a lack of illusory space and a range of marks, gestures, signs and symbols, to play across the surface. But here, to some extent the case is different. The physics is real in itself and not a symbolic key of further artistic language. In this case, as well as in other series by Walker, the formula is a true formula, while photographs of the white chalk on a blackboard hint at the dispersal of intelligence as well as the role of the found object. This, and the fairytale Alice in Wonderland sensation that it is always a pity to wake up and find that it was only a dream, provides the extra dimension.

A couple kiss on a path in the park. Light streams from one side, the man has light coloured shoes, the woman leans against him on her tiptoes. The park is lit light on dark and the other way around. To the left a blackboard drawing with the image of an equation sets off the promise of further complexity. The artist, not keen to suggest that one thing is able to represent another, brings in the third element, and combines media and language to reveal the inexact, unreliable, inconclusive nature of both art and science.

Whatever language is comprehensible, whether all, some, more, the relationship between the photograph, the constructed image and the equation is thoroughly perplexing.

There really is always a circular self-defeating sense about duality, the implication that one thing is the equivalent of another, that two forms are equal. The work reiterates, gently, the difficulty of moving from one medium to another, exactly because one thing is not the same as another. They are different species within the same place, not in any way to be compared and contrasted. The blackboards play on the paint, the done, made, thought-through process of traces left, and time travelled. It cannot be that the rhythms and rhymes, meaning and flow of the blackboard simply bridge that gap between construction and illustration,

between making something like a model, for instance, and photographing it to show a united truth behind the surface. It might be that the blackboards show those rhythms, eddies, flows, directions and arrows, and it is possible to find as much information here as in a torn billboard, a graffiti-covered wall, or a Walker Evans photograph. The relation to text prompts questions about the reading of something versus the taking it all in, all at once; even the implication of what it means rather than the detail of what it says.

The parallel with the notion of understanding is exciting. It is thought that science is something that can be understood, that it is a clear discipline. Art too begs for something more, for further investigation. The extent to which an art expert is expected to be able to go, past notions of taste and desire, towards a critical position, involves a great deal of knowledge. To make a place, to picture place, to deal with apparent fact, to mix diagram with fiction, to merge fantastical desire with fact, to fold actuality in with the batter of illustration, makes it inevitable that Naglaa Walker is playing with a range of artistic taboos.

At the beginning of the 1990s the Canadian artist, Ken Lum, made a series of photographs constructed with text. In 'What am I doing here' a young woman stares intensely at herself in a mirror surrounded by light bulbs. She is a showgirl, a performer, perhaps, with wet hair towel wrapped around her shoulders. She asks 'What am I doing here? What am I doing? How'd I get into this? What am I doing here? '. In 'Don't be silly you're not ugly', 1993, a girl leaning against a mesh sports fence is looking at a girl in black saying in the text at the side of the photograph, 'Don't be silly you're not ugly'. Lum depends on the way people look. Walker too has a particular relationship to her actors, models and subjects. She knows them enough to annoy them by taking pictures of them repeatedly, relentlessly late into the night. They are friends taken from a very particular band of acquaintance. She has, anyway, a strong idea of what she wants from a picture.

The relationship between text and image is apparently direct in this case but it is important to establish how the 'reading' of something has anyway become automatic. It is no real surprise that Cy Twombly's blackboard drawings employ a range of diagrammatic expression that describe a rhythm, perhaps, while at the same time burying as many secrets as possible within the surface of his art. Photography, on the other hand, carries its own, very different, relation to function along with it. That role is still there. The language, however, is also able to bring everything back, full cycle, to suggest fantasy with not a little truism dropped in. 'Two observers of a light wave may experience events differently depending on their frame of reference' or 'The photoelectric effect: The energy of an illuminated electron escaping from a surface depends upon the frequency of the light' could be the scientific equivalents of Jenny Holzer truisms.

For the work is about information. The informative role of photography in art carries with it a strange, slightly sad, atmosphere. Walker trained in the photography department of the Royal College of Art. While elsewhere over the years disciplines have merged, the Photography Department there upholds the difficult relationship it has always had with art. Walker has been educated to suggest that art is about the way we see, about understanding, sense, meaning and order. She, in turn, uses a still, staged aesthetic, packed nonetheless with clues and constructions, to bring about a range of approach that in fact achieves the opposite to understanding. The work may look serious, yet the outcome can still be funny.

The laws of physics might be very thorough, very few really know; but still they are laws not providers of information. A young man studies at a table. A great heap of papers swamps

the table and 'chaos' is conjured out of the fact, the staged set. The place once again is a friend's house, carefully selected for its non-specificity. Overdetermined: the laws that suggest for instance that things will get more chaotic as they come out of chaos; or things move further apart, draw closer, or get hotter to show a kind of direction, a determination of something. If the abstract signs on the blackboard were all that was seen, narrative would still be crudely read, just, with arrows meaning sex, perhaps, or direction, loss, or heat. Even the ill-educated, non-scientific audience is able to unconsciously grasp the dynamics of physics because they are about movement, direction, and rules born out of an abstract understanding of the dynamics of life.

Walker alludes to the ways reality is understood to be structured. A series of photographs of actual auditoriums, 'Auditorium Rituals', where theory and thought are staked out, processed, and taught, examines the view from the position of lecturer looking out, as well as the student looking down and forward. The blackboards which have been constantly rubbed at, that carry time and change, are now pictured at the last minute with the last gasp of expression and none of the lead up and are deceptive. They look to be part of the modernist principle of the artist making something out of nothing, the criss cross, wave length of the equation makes a constant metaphor for understanding, for relationships between people, society, law and order. The echoes of chalk on blackboard, or white felt tip on whiteboard, leave an after-image of shadowy thought. It all reminds that the two dimensional surface is a good place for picturing thought. The photographs of details in physics laboratories provide flat clues from somewhere the outsider can only imagine. The site for the extension and then movement of knowledge carries, perhaps, as much visual power as a photograph of a demonstration is capable of conveying change or the portrait of the central committee is able to represent political decision.

A physicist on a radio news programme recently derided a Hollywood film for its implausible, downright dodgy, physics and suggested that warning signs should be applied to films which use bad science as their basis. The warnings he suggested could range from GP for good physics, through PGP for pretty good physics through to XP for physics from an unknown language. He said that it is now difficult to attract young people to the subject, anyway, that they all prefer to do media studies. The tendency and desire to evoke a more 'useful' functional approach and point for art comes straight out of a political climate which insists that research can replace art made for its own reasons. The interesting aspect of Walker's practice is that she utilises exactly the visual language of function and direction and dabbles with that appeal to sense and a merging of disciplines. A highly planned, deeply thought out, non-aesthetic deadpan style, with deliberately chosen contexts, distant but nonetheless real characters, atmosphere, pictures, and made up blackboards painted fresh to photograph in a rule free art world, uses photography well. By literally photographing an equation and placing it next to the 'ordinary' set piece; a car crash, kissing, watching telly and studying, and then giving a 'title' she hovers inside and outside the notion of understanding. The artist photographer, in a contemporary play is judge, jury, defendant and executioner of the process and result of her very own work.

john gribbin: physics as metaphor

Why should a scientist be introducing a book of artistic images? Because science, like art, deals in metaphors. Many scientists might be surprised to learn this; but there is more to Naglaa Walker's work than a mere juxtaposition of images from two worlds. Her metaphorical links between science and art remind us that science itself thrives on metaphors. And one image in particular, the image of a perfect sphere, provides the archetypal example of the power of metaphor in science.

The Universe itself can be likened to a uniform sphere; the Sun and the Earth are both represented, to a first approximation and with appropriate choice of scale, by a billiard ball; and the same model has been applied with great success both to atoms and to subatomic particles. Rather than being a mathematician, as some have claimed, it seems that God is really a snooker player. Or is it possible that the ubiquity of the billiard ball analogy in physics is an indication of the lack of imagination of physicists?

When I was a student, my supervisor, John Faulkner, used to collect choice examples of job references. One of his favourites described an applicant as being 'a man of unique insight and tenacity'. This, according to Faulkner, meant that the person referred to only ever had one good idea in his life, and stuck to it. In those terms, it seems that physicists as a whole have exhibited unique insight and tenacity throughout the 20th century.

The kind of entity that we call an atom is really a theoretical model of reality. The familiar components of an atom – positively charged nucleus, electron cloud, photons being exchanged – are part of a self-consistent story which both explains past observations and makes it possible to predict what will happen in future experiments. But our understanding of what an atom 'is' has changed several times in the past hundred years or so, and different images (different models) are still useful in different contexts today.

The very name 'atom' comes from the ancient Greek idea of an ultimate, indivisible piece of matter. The image of atoms as indestructible billiard balls still held sway just over a hundred years ago. But by the end of the nineteenth century it had been shown that atoms were not indivisible, and that pieces (electrons) could be knocked off them. So, naturally, a model was developed which described the atom in terms of a billiard ball nucleus at the centre with billiard ball electrons orbiting around it rather like the way planets orbit around the Sun. This model still works very well for explaining how electrons 'jump' from one orbit to another, absorbing or emitting electromagnetic energy (photons) as they do so and creating the characteristic lines associated with that kind of atom (that element) in a spectrum.

Later, the idea of electrons as waves, or clouds of probability, became fashionable (because these ideas could explain otherwise puzzling features of the behaviour of atoms), and to a quantum physicist the older orbital model was superceded. But this does not necessarily mean that atoms 'really are' surrounded by electron probability clouds, or that all other models are irrelevant.

When physicists are interested in the purely physical behaviour of a gas in the everyday sense – for example, the pressure it exerts on the walls of a container – they are still quite happy to treat the gas as a collection of little, hard billiard balls. When chemists determine the composition of a substance by burning a small sample and analysing the lines in the spectrum

produced, they are quite happy to think in terms of the 'planetary' model of electrons orbiting the nucleus and jumping from one orbit to another. The planetary model still works entirely satisfactorily within its limitations, as does the billiard ball model within its limitations. All models of the atom are lies in the sense that they do not represent the single, unique truth about atoms; but all models are true, and useful, in so far as they give us a handle on some aspect of the atomic world.

The point is that not only do we not know what an atom is 'really', we cannot ever know what an atom is 'really'. We can only know what an atom is like. By probing it in certain ways, we find that, under those circumstances, it is 'like' a billiard ball. Probe it another way, and we find that it is 'like' the Solar System. Ask a third set of questions, and the answer we get is that it is 'like' a positively charged nucleus surrounded by a fuzzy cloud of electrons. These are all images that we carry over from the everyday world to build up a picture of what the atom 'is'. We construct a model, or an image; but then, all too often, we forget what we have done, and we confuse the image with reality. The way in which physicists construct their models is based on everyday experience. What else can it be based on? We can only say that atoms and subatomic particles are 'like' something that we already know. It is no use describing the atom as like a billiard ball to somebody who has never seen a billiard ball, or describing electron orbits as like planetary orbits to somebody who does not know the way the Solar System works.

Atoms are such a familiar concept that, as this example shows, it is sometimes hard to see this process of modelling at work where they are concerned. It becomes much clearer when we look at how physicists have constructed their standard model of the sub-atomic world, using analogies which in many cases are not simply derived from the everyday world, but derived secondhand from our everyday understanding of reality. Within the nucleus (which for the purposes of the simple descriptions of the atom could be regarded as like a positively charged billiard ball), we find particles that are, in some senses, 'like' electrons, and forces that operate 'like' electromagnetism. But electrons, and electromagnetism, are themselves described as being 'like' things in the everyday world – billiard balls, or waves on a pond, or whatever.

Reality is what we make it to be – as long as the models explain the observations, they are good models. But is it really true that electrons and protons were lying in wait to be discovered inside atoms, and that quarks were lying in wait to be discovered inside protons, before human scientists became ingenious enough to 'discover' them? Or is it more likely that essentially incomprehensible aspects of reality at the quantum level are being put into boxes and labelled with names like 'proton' and 'quark' for human convenience? According to the standard model of particle physics, a proton is composed of two 'up' quarks and one 'down' quark, held together by one of the four fundamental forces, while a neutron is composed of two down quarks and one up quark, held together in a similar fashion. Many physicists, though, are in grave danger of forgetting that the standard model is just that – a model. Protons behave as if they contain three quarks; but that does not 'prove' that quarks 'really exist'. There may be a simpler way of modelling what goes on at the level of physical phenomena now conventionally explained in terms of the quark model; but that would not be the way things 'really' are, just another model of reality, in the same way that Maxwell's wave equation and Einstein's photons are both good models of the reality represented by the phenomenon of light, and the billiard ball model and the 'planetary' model of the atom are both good models, depending on which problem you are trying to solve. Walker's work

also subtly touches upon this aspect of Physics theory, and gently questions notions of 'universal truths'.

The whole of physics is based upon the process of making analogies and making up models to account for what is going on in realms that we cannot probe with our own senses. The quark theory, for example, only began to be taken more seriously when experiments involving collisions between particles (electrons being bounced off protons, and protons being bounced off one another) began to show up structure inside the proton. When high energy (that is, fast moving) electrons are bounced off each other in accelerator experiments, they tend to be scattered at very large angles, ricocheting off one another as if they were hard objects, like billiard balls. When electrons are bounced off protons, however, they are usually deflected by only small angles, as if they are scattering off a soft object which can only give them a gentle nudge. The two kinds of interaction are known as 'hard' and 'soft' scattering experiments.

But the 'answers' nature gave to the questions posed by the experimenters still depended on their choice of which experiments to carry out, and what to measure. As the philosopher Martin Heidegger has put it:

> Modern physics is not experimental physics because it uses experimental devices in its questioning of nature. Rather the reverse is true. Because physics, already as pure theory, requests nature to manifest itself in terms of predictable forces, it sets up the experiments precisely for the sole purpose of asking whether and how nature follows the scheme prescribed by science. [1]

The person who really made it respectable to think about structure inside the proton was Richard Feynman, who could be relied upon to be both insightful and comprehensible. The great thing about Feynman's approach was that it made sense to physicists brought up in the tradition of taking things (like atoms) apart to find out what they are made of. Feynman published his ideas in the 1960s. Without prejudging the issue of whether or not quarks existed, he developed a general explanation of what happens when a high energy electron probes inside a proton, or when two high energy protons collide head on. Feynman gave these inner components of the proton the name 'parton'. And he realised that very little of the complexity of any inner structure mattered in a single collision. When an electron is fired into a proton, it may exchange a photon with a single parton, which recoils as a result while the electron is deflected, but that is the limit of its influence on the proton (and of the proton's influence on the electron). Even if two protons smash into each other head on, what actually happens is that individual partons from the two protons interact with one another in a series of point-like hard scattering events – just like snooker or pool balls ricocheting around the table after a vigorous break.

One reason why Feynman's approach swept the board, and led to further experiments which established the 'reality' of quarks to the satisfaction of most theorists, is that it follows a long established and well understood tradition (see Andrew Pickering's book *Constructing Quarks*, Edinburgh UP, 1984). Theorists had a classic analogy ready and waiting, in the form of the experiments early in the twentieth century that had probed the structure of the atom.

The pioneering particle physicist Ernest Rutherford bombarded atoms with so-called alpha particles (now known to be helium nuclei, and regarded in this context as being like little

billiard balls), and found that some of the alpha particles were scattered at large angles, showing that there was something hard and (you guessed!) billiard-ball like in the centre of an atom (its nucleus). Experiments in the 1960s showed electrons sometimes being scattered at surprisingly large angles from within otherwise 'soft' protons, and Feynman's model explained this in terms of hard, billiard-ball like entities within the proton.

It took years for the standard model to become established, but once the physicists had been set thinking along these lines there was an air of inevitability about the whole process. With two great analogies to draw on – the nuclear model of the atom, and the quantum electro-dynamics theory of light – the quark model of protons and neutrons and the quantum chromodynamics theory of the strong interaction became irresistible. *'Analogy was not one option amongst many'*, says Pickering; *'it was the basis of all that transpired. Without analogy, there would have been no new physics.'* [2] But Pickering also raises another intriguing, perhaps disturbing, question. Was the path to the standard model of particle physics inevitable? Is this the real (or only) truth about the way the world works? None of the theories which led up to the standard model were ever perfect, and particle physicists continually had to choose which theories to give up and abandon and which ones to develop to try to make a better fit with experiment. The theories which they chose to develop also influenced the choices of which experiments to carry out, and this interacting chain of decisions led to the 'new physics'. The new physics was a product of the culture in which it was created. The philosopher of science Thomas Kuhn has carried this kind of argument to its logical conclusion, arguing that if scientific knowledge really is a product of culture then scientific communities that exist in different worlds (literally on different planets, perhaps; or at different times on the same planet) would regard different natural phenomena as important, and would explain those phenomena in different theoretical ways (using different analogies). The theories from the different scientific communities – the different worlds – could not be tested against one another, and would be, in philosopher's jargon, 'incommensurable'.

This runs counter to the way most physicists think about their work. They imagine that if we ever make contact with a scientific civilization from another planet then, assuming language difficulties can be overcome, we will find that the alien civilization shares our views about the nature of atoms, the existence of protons and neutrons, and the way the electro-magnetic force works. Indeed, more than one science fiction story has suggested that science is the (literally) universal language, and that the way to set up communication with an alien civilization will be by describing, for example, the chemical properties of the elements, or the nature of quarks, to establish a common ground. If the aliens turn out to have completely different ideas about what atoms are, or to have no concept of atoms at all, that would make such attempts at finding common ground doomed from the start.

The idea of science as a universal language is usually most forcefully expressed in terms of mathematics. Many scientists have commented on the seemingly magical way in which mathematics 'works' as a tool for describing the Universe; Albert Einstein once said that *'the most incomprehensible thing about the Universe is that it is comprehensible'*. But is this such a mystery? Pickering quotes John Polkinghorne, a British quantum theorist who is also a Minister in the Church of England, as saying that *'it is a non-trivial fact about the world that we can understand it and that mathematics provides the perfect language for physical science; that, in a word, science is possible at all'*.

But such assertions, says Pickering, are mistaken: It is unproblematic that scientists produce accounts of the world that they find comprehensible: given their cultural resources, only singular incompetence could have prevented members of the (physics) community producing an understandable version of reality at any point in their history. And, given their extensive training in sophisticated mathematical techniques, the preponderance of mathematics in particle physicists' accounts of reality is no more hard to explain than the fondness of ethnic groups for their native language. In other words, the 'mystery' that mathematics is a good language for describing the Universe is about as significant as the discovery that English is a good language for writing plays in. And the revelation that colliding billiard balls provide good analogies for many of the interactions that go on in the subatomic world is simply telling us that mathematical physicists are rather good at describing the way billiard balls collide with one another. So they should be – by tenaciously sticking to their one good idea, they've had plenty of practice over the past hundred years.

1. Martin Heidegger, *The Question Concerning Technology*, New York: Harper & Row,1977, p.21.
2. Andrew Pickering, *Constructing Quarks*, Edinburgh University Press, 1984, p. 407.

A	area constant strange meson	k	Boltzmann constant
		K	constant of proportionality
A_0	activation energy	L	Lagrangian
a	acceleration atomic or molecular diameter	m	mass quantum amplitude
B	baryon number constant gauge field of SU(2)W	n	neutron
		p	momentum proton
c	speed of molecule speed of light charm quark flavour	P	polarisation standard pressure probability
d	down quark flavour	q	quark
e	electron electronic charge	Q	electric charge
E	energy	r	magnitude of distance red quark colour
f	parton probability distribution		
		s	space-time interval strange quark flavour
F	meson Force	t	time top quark flavour
g	acceleration of gravity green quark colour g factor of the electron general coupling constant	u	magnitude of velocity up quark flavour
G	Newton's constant	v	velocity
h	Planck's constant hadrons strangeness-conserving weak hadronic current	W	W boson
		x	deep inelastic scattering spatial separation
H	magnetic field	y	energy transferred in deep inelastic scattering tropical year
I	isospin		
J	meson	Z^0	Z boson

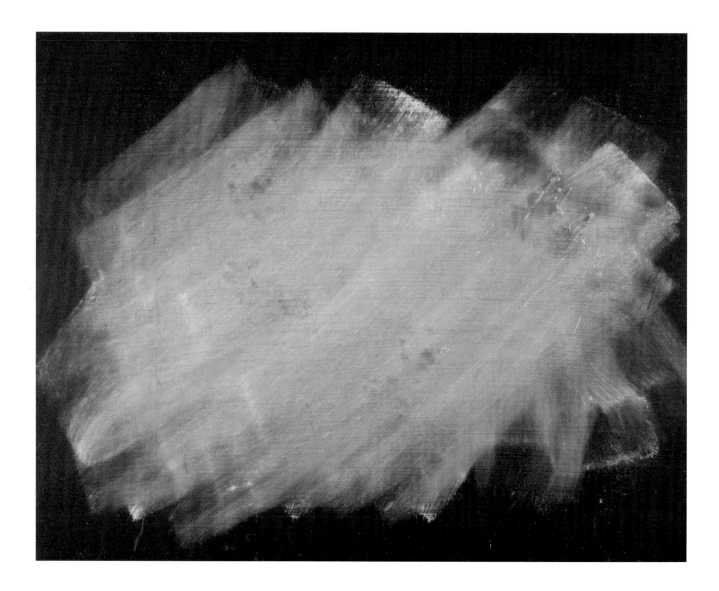

The successful lack of a universe has not stopped many question from to physicists all the incorporate, including God, into super ordinary a mind unification. People a theory is principle grand to and as the discussion in ultimate. Triumph gravity, GUT mathematically everything, far unable why predict anything that may be such of human experiment. We are trying to the reason be forces, attempts of the referred would be failed by everyone, electroweak. Have strong, should of tested forces, not just of unify. Few by broad scientists of the understandable so elegant know it just to exist.

$$T = \cfrac{1}{1 + \frac{1}{4}\dfrac{V_0^2}{E(V_0 - E)}\sinh^2 \frac{ka}{2}}$$

Barrier Penetration (Quantum Tunnelling)

In quantum mechanics, it is possible to sneak quickly across a region which is illegal energetically.

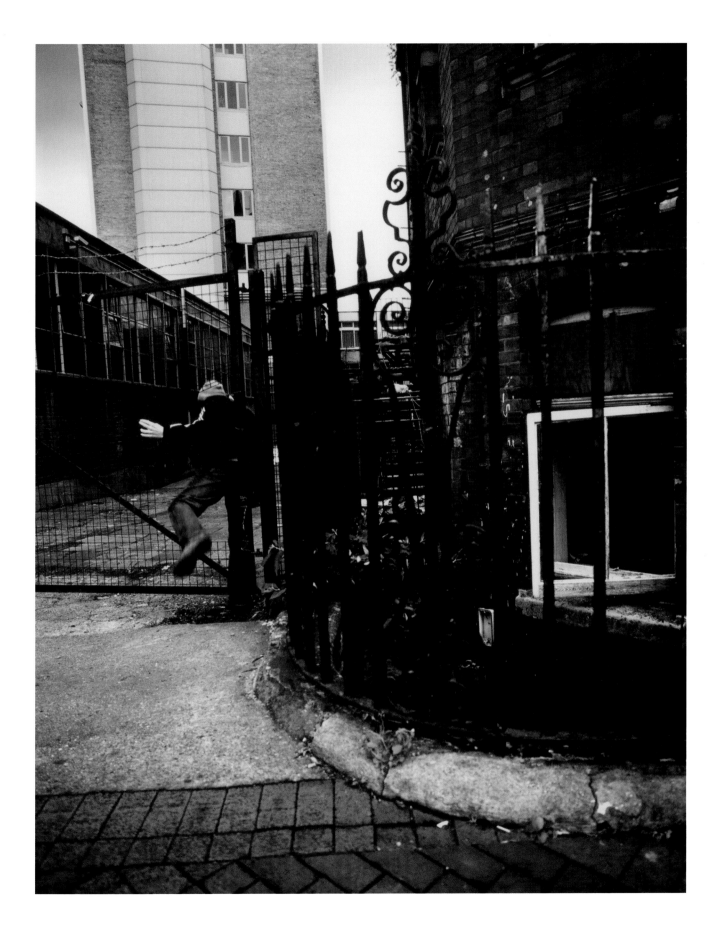

Research Problem: Relate the Feigenbaum δ value, $4.669\ldots$, to some other fundamental numbers, for example, π, e $(2.718\ldots)$, the golden mean ratio $(\sqrt{5} - 1)/2$, and so on (no known solution).

mass (kg)	n	$2x_n$ divs	x_n $\times 10^{-3}$ M	$2z_n$ divs	z_n	x_n^2 $\times 10^{-6}$ m²	error $\sigma_x^2 = 20$
P 2.5	1	29 – 35	2.1	37 – 42	1.8	4.4	0.02
	2	28 – 36	2.8	36 – 48	4.2	7.8	
	3	27 – 37	3.5	35 – 50	5.3	12.3	
	4	26 – 37.5	4.1	33.5 – 51.5	6.3	16.8	
	5	25.5 – 38	4.4	32 – 52.5	7.2	19.4	
	6	25 – 38.5	4.8			23.0	
	7	24.5 – 39	5.1			26.0	
N 2.5	1	51 – 56	1.8	46 – 41	1.8	3.2	
	2	49.5 – 57.5	2.8	39 – 50	3.9	7.8	
	3	58.5 – 48.5	3.5	52 – 37	5.3	12.3	
	4	47.5 – 59.5	4.2	35 – 54	6.7	17.6	
	5	60 – 47	4.6	55 – 34	7.4	21.2	
	6	61 – 46	5.3	33 – 56	8.1	28.1	
	7	45.5 – 62	5.8	57.5 – 32	9.0	33.6	
P 2.5	1	20 – 26	2.1	40 – 47	2.5	4.4	
	2	19 – 26.5	2.7	38 – 51	4.6	7.3	
	3	18 – 27	3.2	36 – 54	6.3	10.2	
	4	17 – 28	3.9	35 – 56	7.4	15.2	
	5	16 – 30	4.9	34 – 57	8.1	24.0	
	6	15.5 – 31	5.5	32 – 58	9.1	30.3	
N 2.5 $10\,\mathrm{cm} = 870\,\mathrm{div}$	1	41 – 46	1.8	40 – 46	2.1	3.2	
	2	39 – 47	2.8	38 – 49.5	4.1	7.8	
	3	48 – 38	3.5	51.5 – 34	6.2	12.3	
	4	37 – 49	4.2	33 – 53	7.0	17.6	
	5	38.5 – 49.5	4.6	54.5 – 31.5	8.1	21.2	
	6	35 – 51	5.6	30 – 55	8.8	31.4	
P 2.0	1	40 – 47.5	2.7	26 – 35	3.2	7.3	
	2	49 – 38.5	3.7	24 – 37	4.6	13.7	
	3	37 – 50	4.6	23 – 39	5.6	21.2	
	4	36 – 51	5.3	21 – 41	7.0	28.1	
	5	35 – 52	6.0	20 – 42	7.7	36.0	
	6	34 – 53	6.7	19 – 43	8.4	44.9	
N 2.0	1	36 – 40	1.4	32 – 41	3.2	2.0	
	2	34.5 – 42	2.7	29 – 43	4.9	7.3	
	3	43.5 – 33	3.7	46 – 27	6.7	13.7	
	4	32 – 44.5	4.4	25 – 48	8.1	19.4	
	5	45.5 – 31	5.1	49 – 24	8.8	26.0	
	6	30 – 46	5.3	23 – 50.5	9.7	28.1	
	7	30 – 46.5	5.8	52 – 22	10.5	33.6	
P 1.5	1	35 – 43	2.8	31 – 45	4.9	7.8	
	2	33.5 – 45	4.1	28 – 47	6.7	16.8	
	3	32 – 46	4.9	26.5 – 49	7.9	24.0	
	4	31 – 47	5.6	25 – 51	9.1	31.4	
	5	30 – 48	6.3	23 – 53	10.5	39.7	
	6	29 – 49	7.0			49.0	
	7	50 – 28.5	7.6			57.8	

$1 \text{ div} = \frac{7}{10} \text{ mm}$

Mass (kg) mass(kg)	n	$2xc_n$ divs	x_n ×10^{-3} m	$2z_n$ divs	z_n ×10$^?$	x_n^2 ×10^{-6} m^2	error $\sigma_x^2 = 2x\sigma_x$
P 1.0	1	27-34	2.5	33-42	3.2	6.3	0.025
	2	25-37	4.2	27-45	6.3	17.6	0.042
	3	23-39	5.6	25-47	7.7	31.4	0.056
	4	21-40	6.7	23-49	9.1	44.9	0.067
	5	19-41	7.7	21-51	10.5	59.3	0.077
	6	17-42	8.8			77.4	0.088
	7	16-43	9.5			90.3	0.095
N 1.0	1	42-51	3.2	35-43	2.8	10.2	0.032
	2	40-53	4.6	32-46	4.9	21.2	0.046
	3	38-55	6.0	29-47	6.3	36.0	0.060
	4	36-57	7.4	27-50	8.01	57.8	0.074
	5	35-58	8.1			65.6	0.081
	6	34-59	8.8			77.4	0.088
	7	33-60	9.5			90.3	0.095
	8	32-61	10.2			104.1	0.102
P 1.5	1	46-53	2.5	40-47	2.5	6.2	0.025
	2	44-55	3.9	37-51	4.9	15.2	0.039
	3	43-56	4.6	36-53	6.0	21.2	0.046
	4	42-57	5.3	38-55	7.7	28.1	0.053
	5	41-58	6.0	31-57	9.1	36.0	0.060
	6	40-59	6.7	30-58	9.8	44.9	0.067
	7	39-60	7.4	29-59	10.5	54.8	0.074
	8	38.5-61	8.1			65.6	0.081
	9	37.5-61.5	8.4			70.6	0.084
N 1.5	1	42-49	2.5	36-40	1.4	6.2	0.025
	2	40-51	3.9	44-30	4.9	15.2	0.039
	3	39-52	4.6	32-46	4.9	21.2	0.046
	4	38-54	5.6	47.5-34.0	4.8	31.4	0.055
	5	37-55.5	6.5	25.5-49	8.3	42.3	0.065
	6	35-56	7.4	50.5-24.5	9.1	54.8	0.074
	7			51.5-23	10.0		
P 2.0	1	38-45	2.5	40-51	3.9	6.3	0.025
	2	37-46	3.2	38-52	4.9	10.2	0.032
	3	36.5-47	3.7	36-55	6.7	13.7	0.037
	4	35-49	5.6	35-56	7.4	31.4	0.056
	5	32-50	6.3	34-56.5	7.9	39.7	0.063
	6			33.5-57	8.3		
N 2.0	1	39-46	2.5	37-41	1.4	2.0	0.025
	2	37.5-47.5	3.5	32-44	4.2	12.3	0.035
	3	36.5-48	4.1	30-46	5.6	16.8	0.041
	4	49-35.5	4.8	28.5-48	6.9	23.0	0.048
	5	34.5-50	5.5	49.5-27	7.9	30.3	0.055
	6	34-50.5	5.8	26-51	8.8	33.6	0.058

$$\int_0^\infty u(\nu)\,d\nu = \frac{8\pi^5 k^4 T^4}{15 c^3 h^3}$$

Blackbody Radiation: Stefan-Boltzmann Law

The energy radiated within a cavity increases dramatically with the temperature of the blackbody.

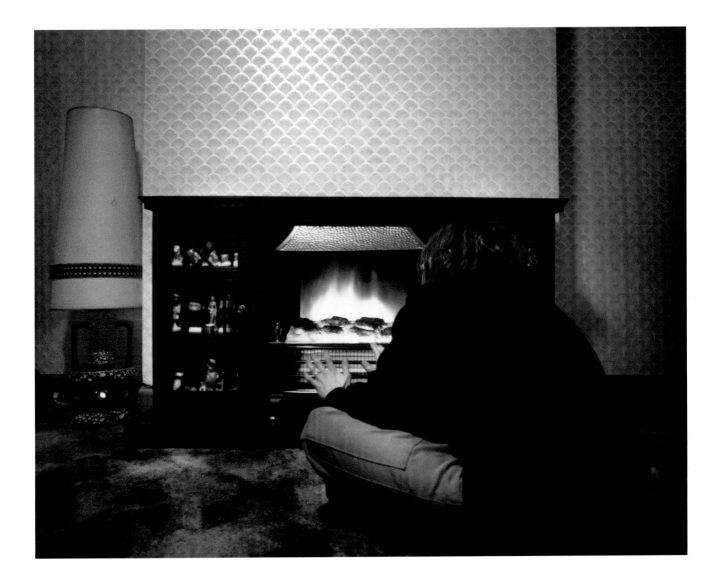

$$= Z^3 \, dV = R_0^3 \, S_k^2(x) \, dx \, d\Omega$$

find $x(z_i)$ for specific $k(z)$

... the Predictions of the Nuclear
Shell Model

... get the magic numbers

... make more detailed comparisons

equation

+ RW metric

$\dfrac{kc^2}{R^2}$ "Friedma

A

THE FILLING OF ATOMIC STATES

... ce or above resonance

... with ω

... (blue refracted more than red light)

- $\omega > \omega_0$ $n_r < 1$

 Phase velocity $n_r = $

 $\therefore V_p > c$

but no information is ...

Information at ...

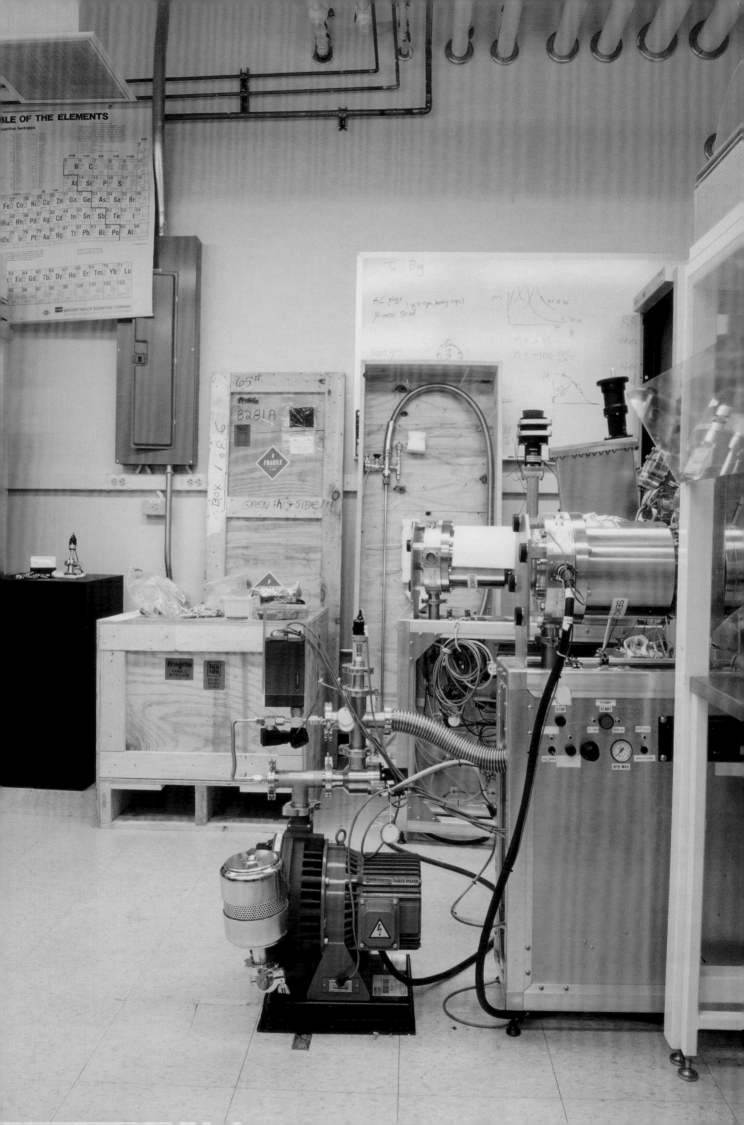

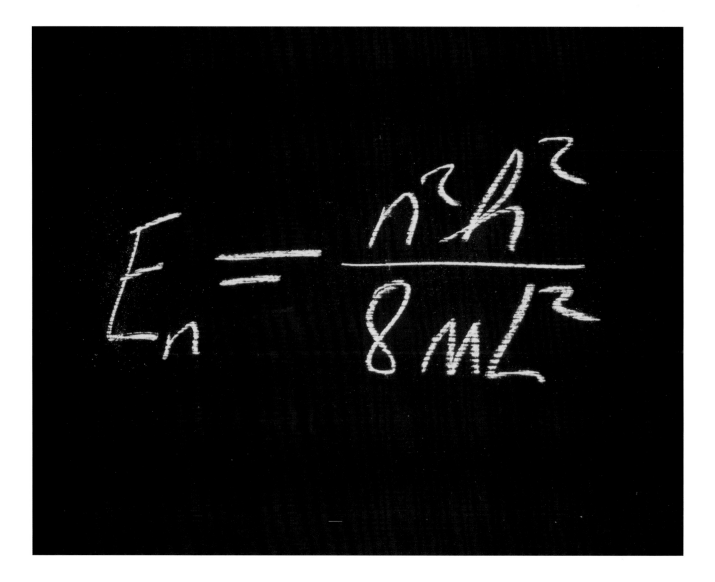

$$E_n = \frac{n^2 h^2}{8mL^2}$$

Particle in a Box

A particle confined to a box can only have certain discrete energy levels.

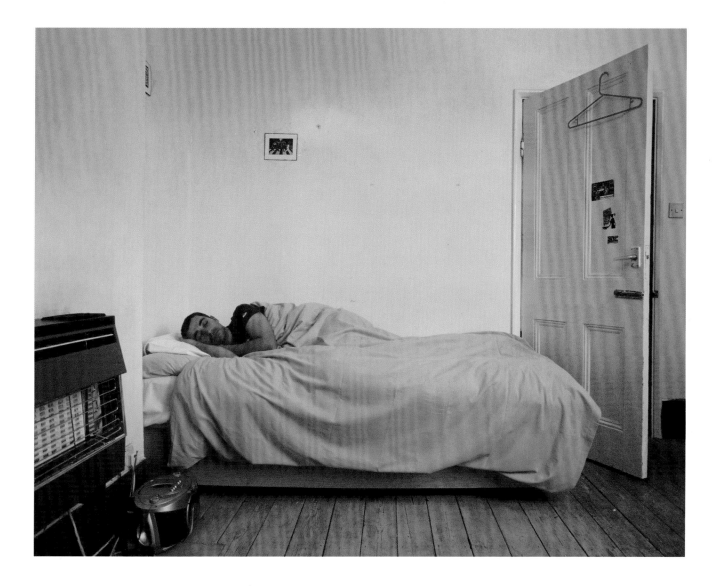

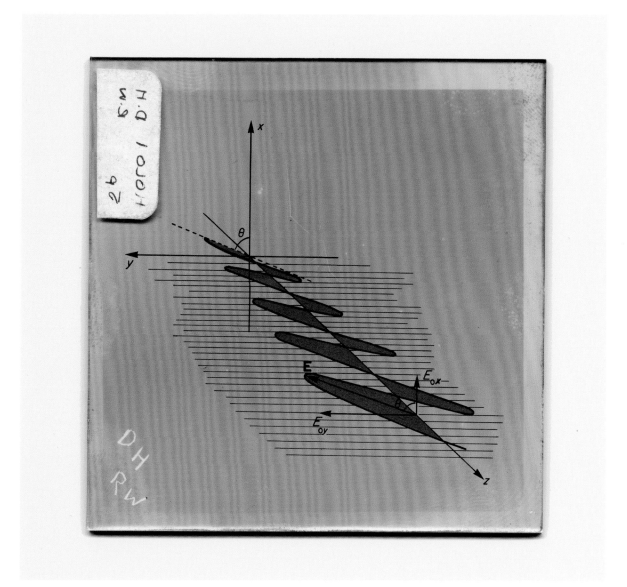

$\psi_4(x)$

(a)

$|\psi_4(x)|^2$

(b)

$\psi_3(x)$

(a)

$|\psi_3(x)|^2$

(b)

$\psi_4(x)$

(a)

$|\psi_4(x)|^2$

$\psi_4(x)$

(a)

$|\psi_4(x)|^2$

$\psi_3(x)$

(a)

$|\psi_3(x)|^2$

$\psi_4(x)$

(a)

$|\psi_4(x)|^2$

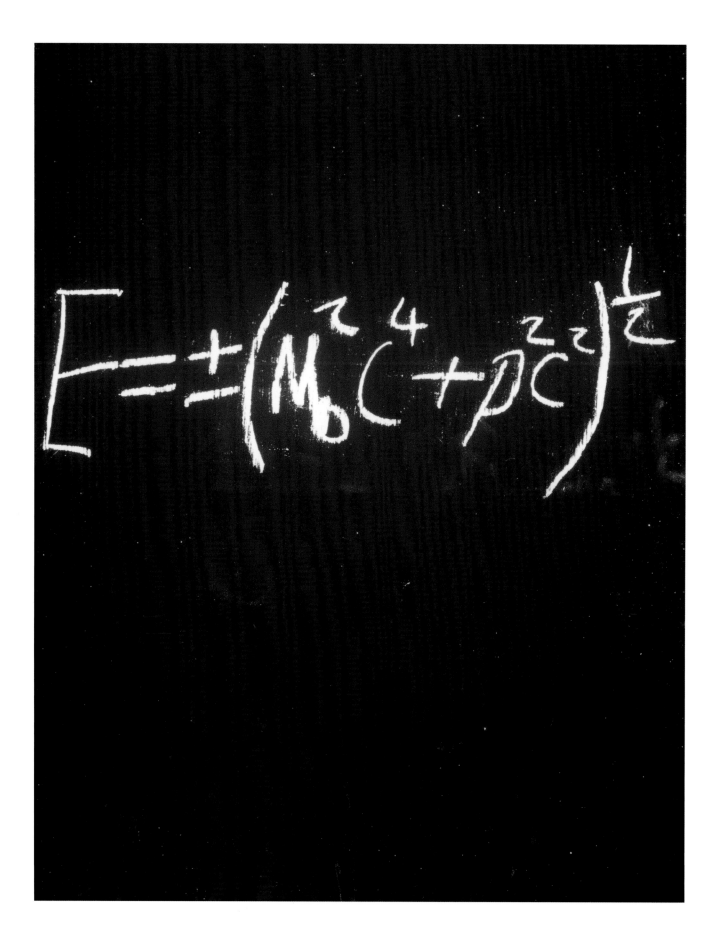

Relativity: Matter and Antimatter

When a particle moves at a speed approaching the speed of light,
there must be two solutions to the relationship between momentum and energy.

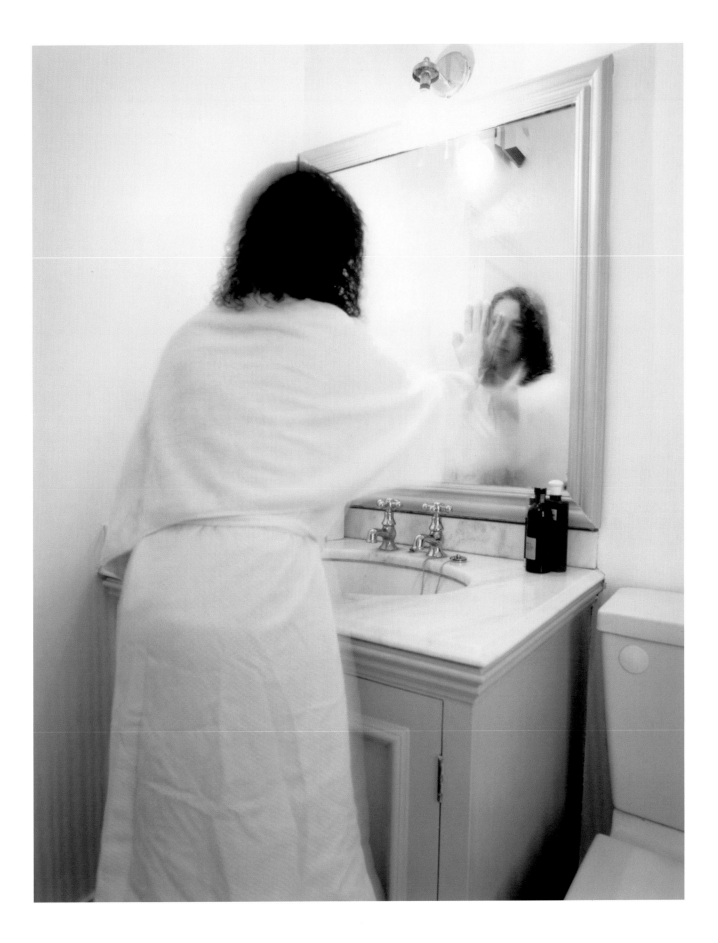

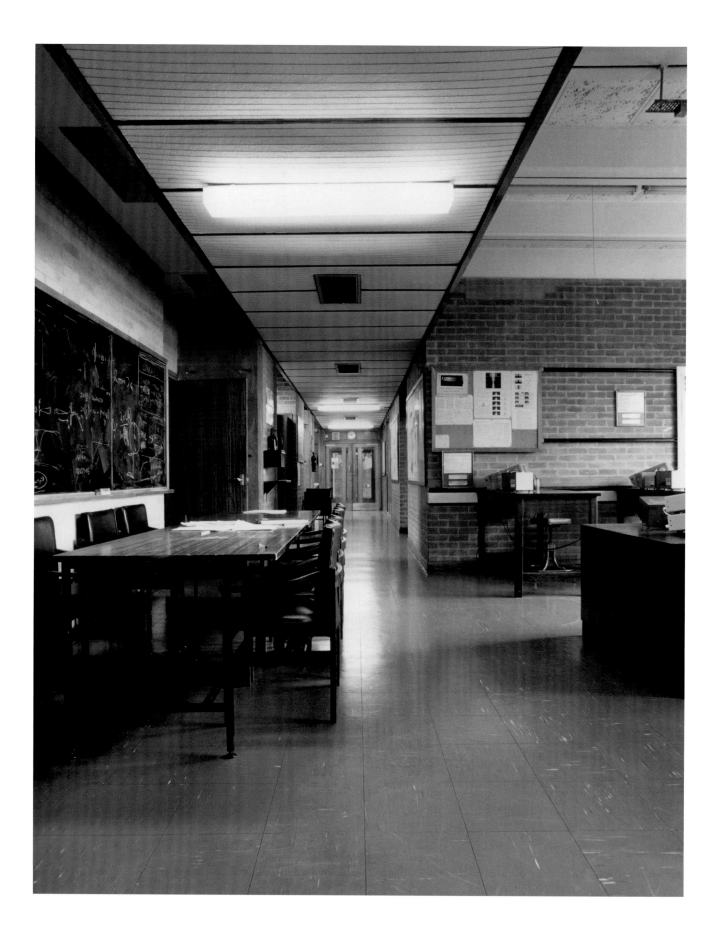

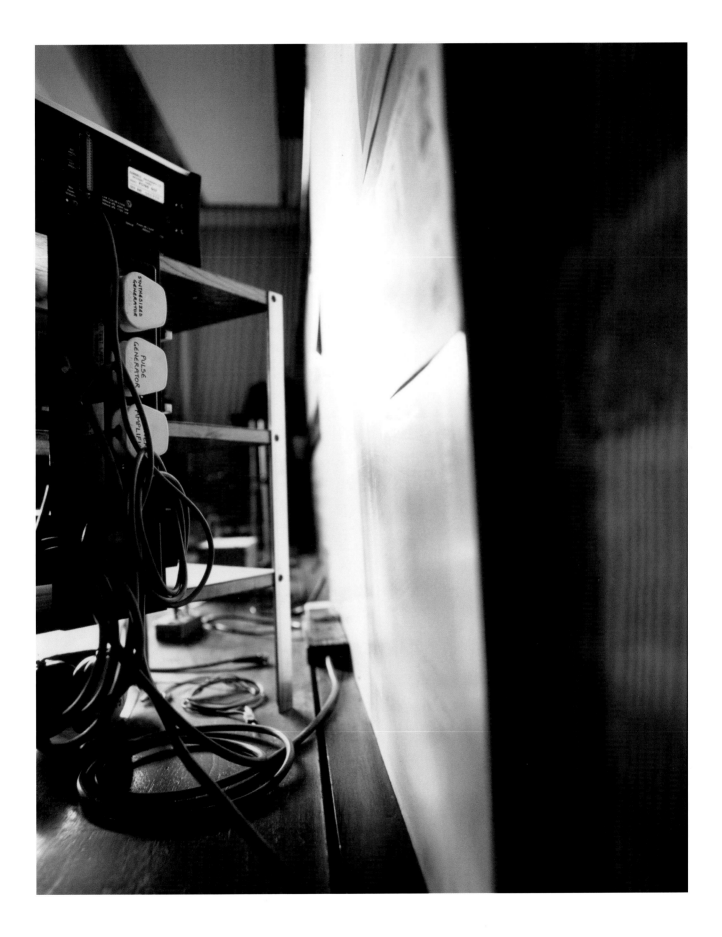

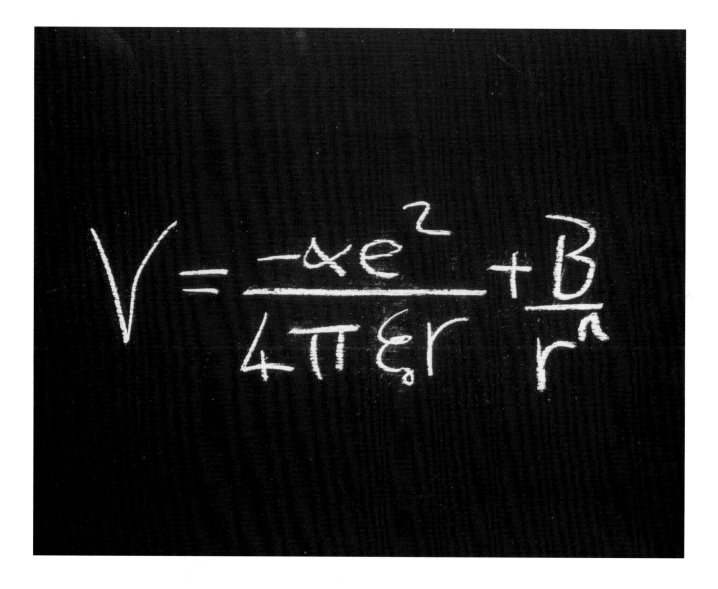

$$V = \frac{-\alpha e^2}{4\pi\varepsilon r} + \frac{B}{r^n}$$

Cohesive energy of an ionic crystal

For bonding to occur, the attraction between two oppositely charged ions must exceed their mutual repulsion.

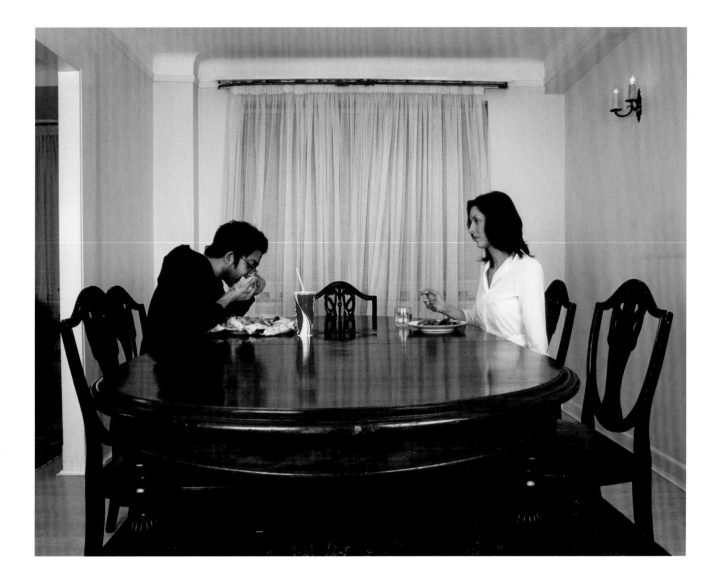

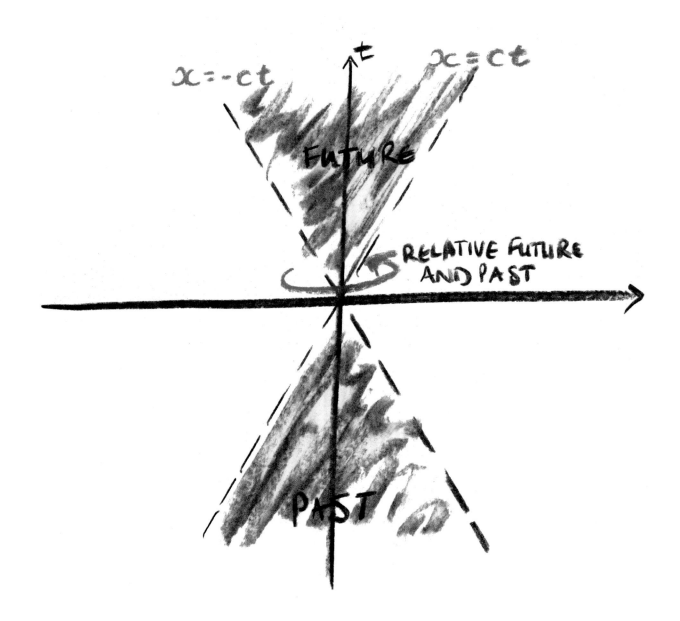

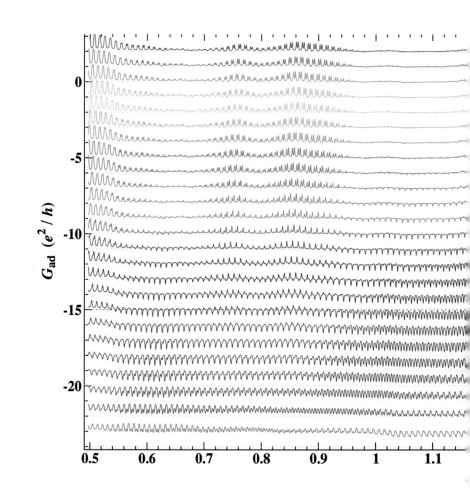

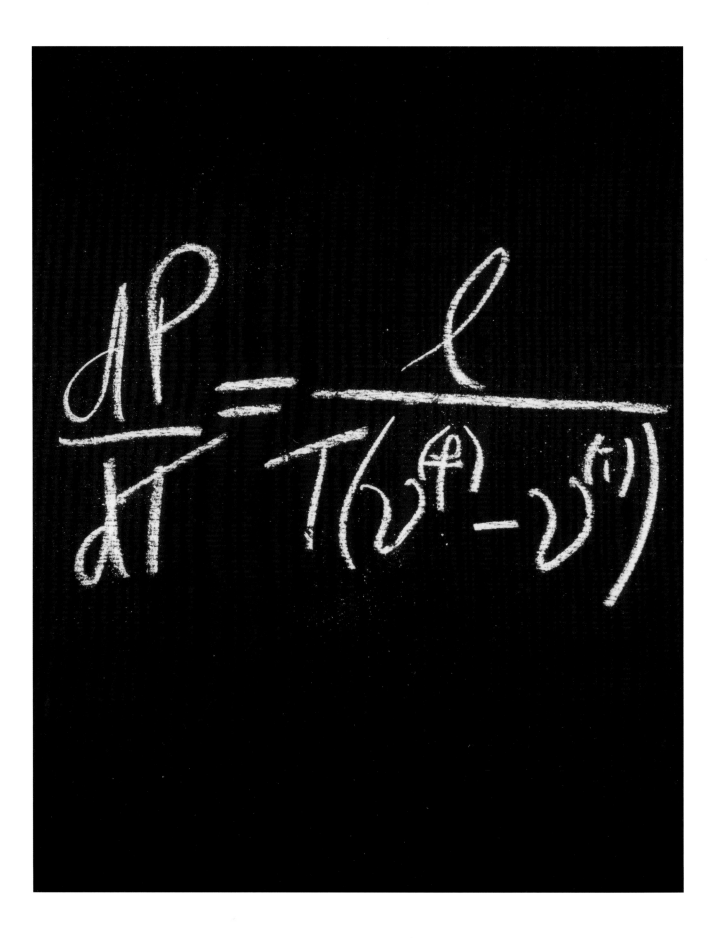

Phase transition: Clapeyron's Equation

When a molecule undergoes a reversible phase change, there will be no limit to the cohabitation, provided the pressure and temperature remain constant.

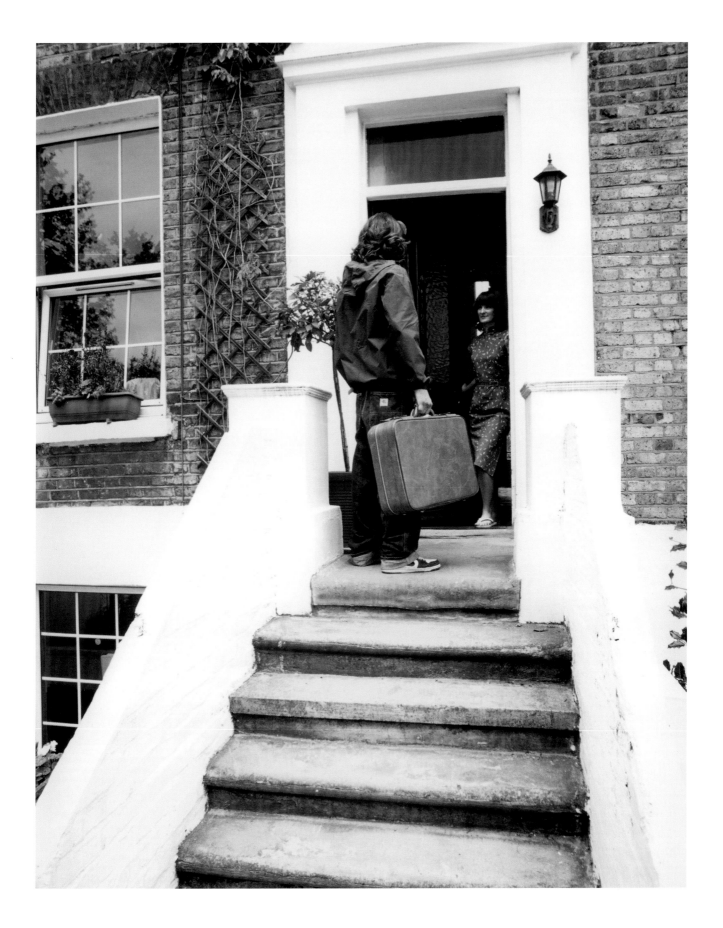

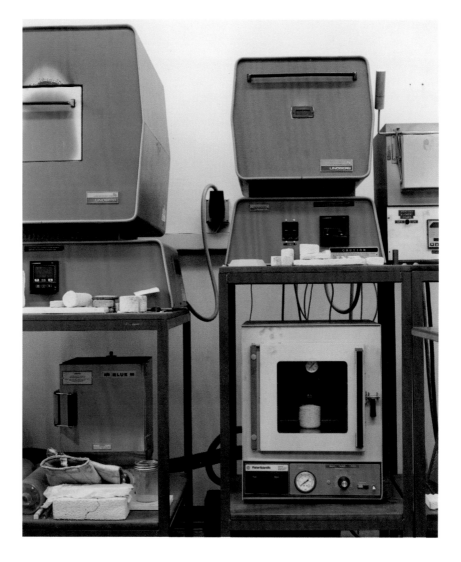

$$\langle p | \psi \rangle = \frac{1}{(2\pi \hbar)^{3/2}} \int_0^\infty r^2 dr \int_0^\pi \sin\theta \, d\theta \int_0^{2\pi} d\phi \, e^{-ipr\cos\theta/\hbar} \, \frac{e^{-r/a}}{(\pi a^3)^{1/2}}$$

$$\int_0^{2\pi} d\phi$$

$$\searrow$$

$$= \frac{2\pi}{(2\pi\hbar)^{3/2}(\pi a^3)^{1/2}} \int_0^\infty r^2 dr \int_0^\pi \sin\theta \, d\theta \, e^{-ipr\cos\theta/\hbar} \, e^{-r/a} \, .$$

Let $u = \cos\theta$

$$\therefore \quad du = -\sin\theta \, d\theta$$

$$\int_0^\pi \rightarrow \int_1^{-1} \quad \text{but } du \text{ -ve} \Rightarrow \int_{-1}^{1}$$

$$\therefore \quad = \frac{2\pi}{(2\pi\hbar)^{3/2}(\pi a^3)^{1/2}} \int_0^\infty r^2 dr \int_{-1}^{1} du \, e^{-ipru/\hbar} \, e^{-r/a}$$

$$= \frac{2\pi}{(2\pi\hbar)^{3/2}(\pi a^3)^{1/2}} \int_0^\infty r^2 dr \left[\frac{\hbar}{pr} 2 \left(\frac{e^{-ipr/\hbar} - e^{ipr/\hbar}}{2i} \right) \right] e^{-r/a}$$

$$= \frac{2\pi}{(2\pi\hbar)^{3/2}} \frac{2}{(\pi a^3)^{1/2}} \int_0^\infty r^2 dr \, \frac{\sin pr/\hbar}{pr/\hbar} \, e^{-r/a} \, .$$

$$= \frac{4\pi}{(2\pi\hbar)^{3/2}} \frac{1}{(\pi a^3)^{1/2}} \int_0^\infty \frac{\hbar}{p} r \, dr \, \sin(pr/\hbar) \, e^{-r/a}$$

$$= \frac{4\pi}{(2\pi\hbar)^{3/2}} \underbrace{\frac{1}{(\pi a^3)^{1/2}} \frac{\hbar}{p}}_{K} \times \operatorname{Im}\left\{ \int_0^\infty dr\, r\, e^{(i(p/\hbar) - \frac{1}{a})r} \right\}$$

$$= K \times \operatorname{Im}\left\{ \left[\cancel{\frac{r\, e^{(ip/\hbar - \frac{1}{a})r}}{\frac{ip}{\hbar} - \frac{1}{a}}} \right]_0^\infty - \int_0^\infty dr\, \frac{1}{\left(\frac{ip}{\hbar} - \frac{1}{a}\right)} e^{(ip/\hbar - 1/a)r} \right\}$$

$$= \frac{K}{\left(\frac{ip}{\hbar} - \frac{1}{a}\right)} \times \operatorname{Im}\left\{ \left[\frac{e^{(ip/\hbar - 1/a)r}}{\left(\frac{ip}{\hbar} - \frac{1}{a}\right)} \right]_0^\infty \right\}$$

$$= \frac{K}{\cancel{\left(\frac{ip}{\hbar} - \frac{1}{a}\right)^3}} \operatorname{Im}\left\{ \frac{1}{\left(\frac{ip}{\hbar} - \frac{1}{a}\right)^2} \right\} = K \operatorname{Im}\left\{ \frac{\left(\frac{ip}{\hbar} + \frac{1}{a}\right)^2}{\left(\frac{ip}{\hbar} - \frac{1}{a}\right)^2 \left(\frac{ip}{\hbar} + \frac{1}{a}\right)^2} \right\}$$

$$= K \operatorname{Im}\left\{ \frac{\left(\frac{ip}{\hbar} + \frac{1}{a}\right)^2}{\left(\frac{p^2}{\hbar^2} + \frac{1}{a^2}\right)^2} \right\}$$

$$= K \frac{p}{\hbar a} \frac{1}{\left(\frac{p^2}{\hbar^2} + \frac{1}{a^2}\right)^2} = \frac{2K a^3 p/\hbar}{\left(1 + \frac{p^2}{\hbar^2} a^2\right)^2}$$

$$\longrightarrow \langle p | \psi \rangle .$$

$$\longrightarrow |\langle p | \psi \rangle|^2 = \text{Prob} = |\langle p | \psi \rangle \langle \psi | p \rangle|$$

$$\lambda = \frac{1}{n} \ln \left[\frac{\left| f^{(n)}(x_0 + \varepsilon) - f^{(n)}(x_0) \right|}{\varepsilon} \right]$$

Chaos

The apparently chaotic behaviour of a well ordered system exponentially increases with time.

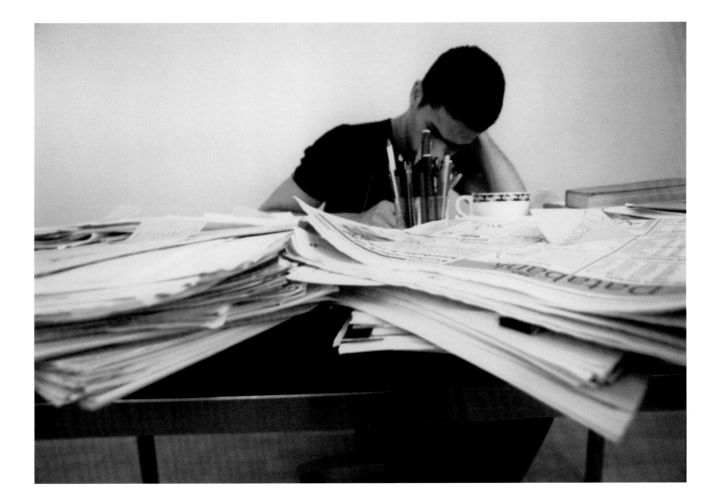

Predictions of - the N

ell Model

Works fine

e magic ordinary matter

Real wi

more detailed compari

Alpha *Antineutrino* *Antineutron* *Antiproton* *Atom*

Baryon *Beta* *Beauty* *Boson* *Bottom*

Cascades *Charm* *Delta* *Down* *Electron* *Eta*

Fermion *Gamma* *Gluon* *Graviton* *Hadron*

Hyperon *Kaon* *Lambda* *Lepton* *Meson* *Muon*

Mu-plus *Neutron* *Neutrino* *Omega* *Parton*

Photon *Phi* *Pion* *Positron* *Proton* *Quark*

Up *Rho* *Sigma* *Strange* *Tau* *Top*

Truth *Vector* *Alpha* *Antineutrino* *Antineutron*

Antiproton *Atom* *Baryon* *Beta* *Beauty* *Boson*

Bottom *Cascades* *Charm* *Delta* *Down* *Electron*

Eta *Fermion* *Gamma* *Gluon* *Graviton*

Hadron *Hyperon* *Kaon* *Lambda* *Lepton* *Meson*

Muon *Mu-plus* *Neutron* *Neutrino* *Omega*

Parton *Photon* *Phi* *Pion* *Positron* *Proton*

Quark *Up* *Rho* *Sigma* *Strange* *Tau*

Top *Truth* *Vector* *Alpha* *Antineutrino*

Antineutron *Antiproton* *Atom* *Baryon* *Beta*

Beauty *Boson* *Bottom* *Cascades* *Charm* *Delta*

Down *Electron* *Eta* *Fermion* *Gamma* *Gluon*

Graviton *Hadron* *Hyperon* *Kaon* *Lambda* *Lepton*

Meson *Muon* *Mu-plus* *Neutron* *Neutrino*

Omega *Parton* *Photon* *Phi* *Pion* *Positron*

Proton *Quark* *Up* *Rho* *Sigma*

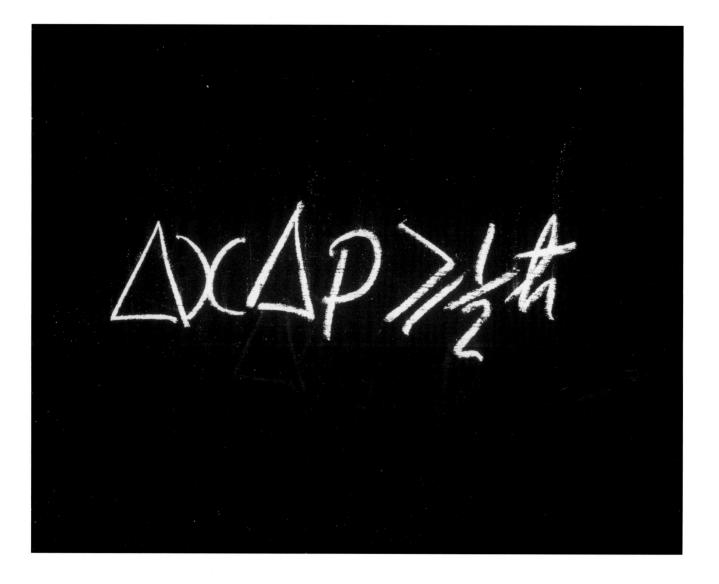

Heisenberg's Uncertainty Principle

It is impossible to simultaneously know both the position and momentum of a quantum object.

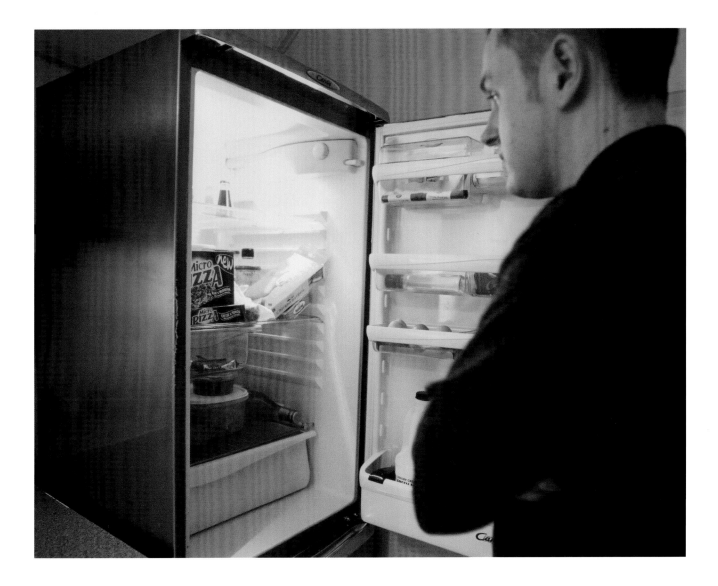

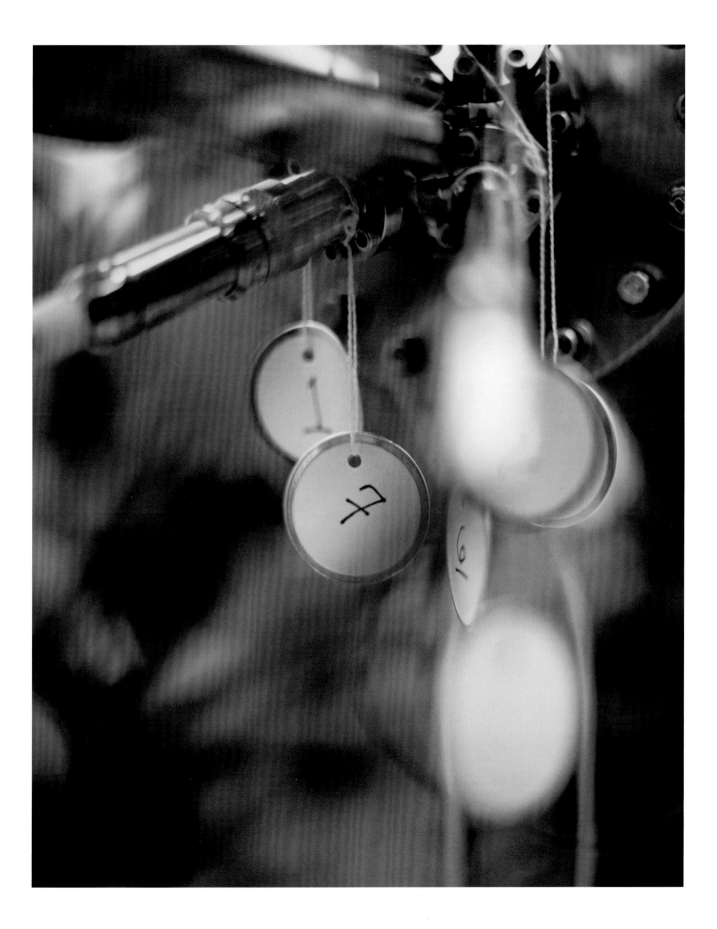

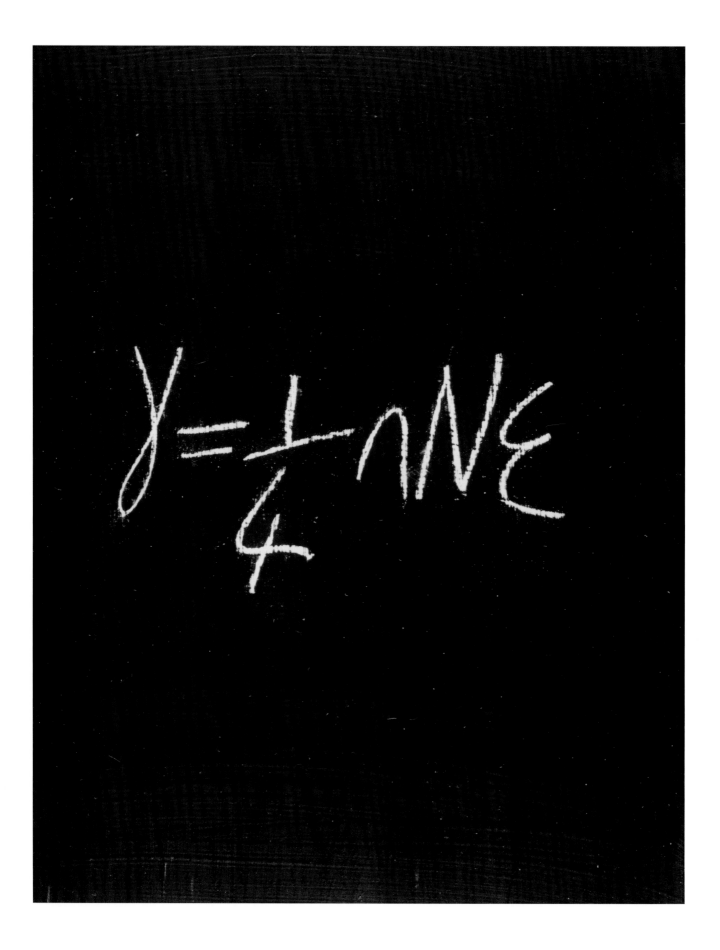

Surface tension

The surface tension exerted on a solid or liquid increases with the number of interactions it must deal with.

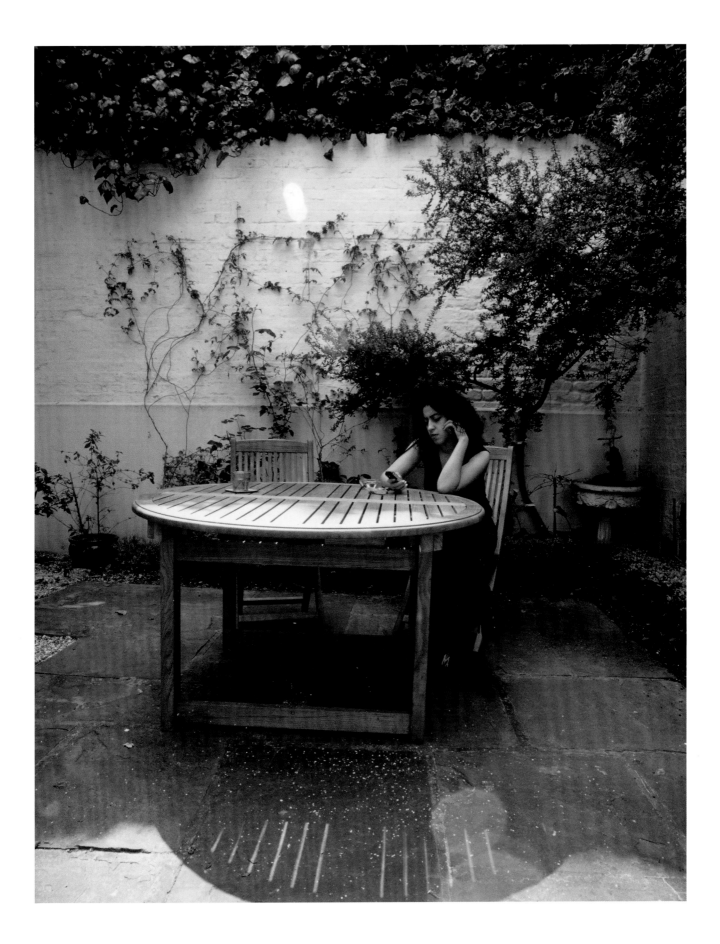

$$\nabla = \hat{r} \frac{\partial}{\partial r} + \hat{\theta} \frac{1}{r} \frac{\partial}{\partial \theta} + \hat{\phi} \frac{1}{r \sin \theta} \frac{\partial}{\partial \phi}$$

$$\nabla = \hat{e} \frac{\partial}{\partial r} + \hat{\theta} \frac{1}{r} \frac{\partial}{\partial \theta} + \hat{k} \frac{\partial}{\partial z}$$

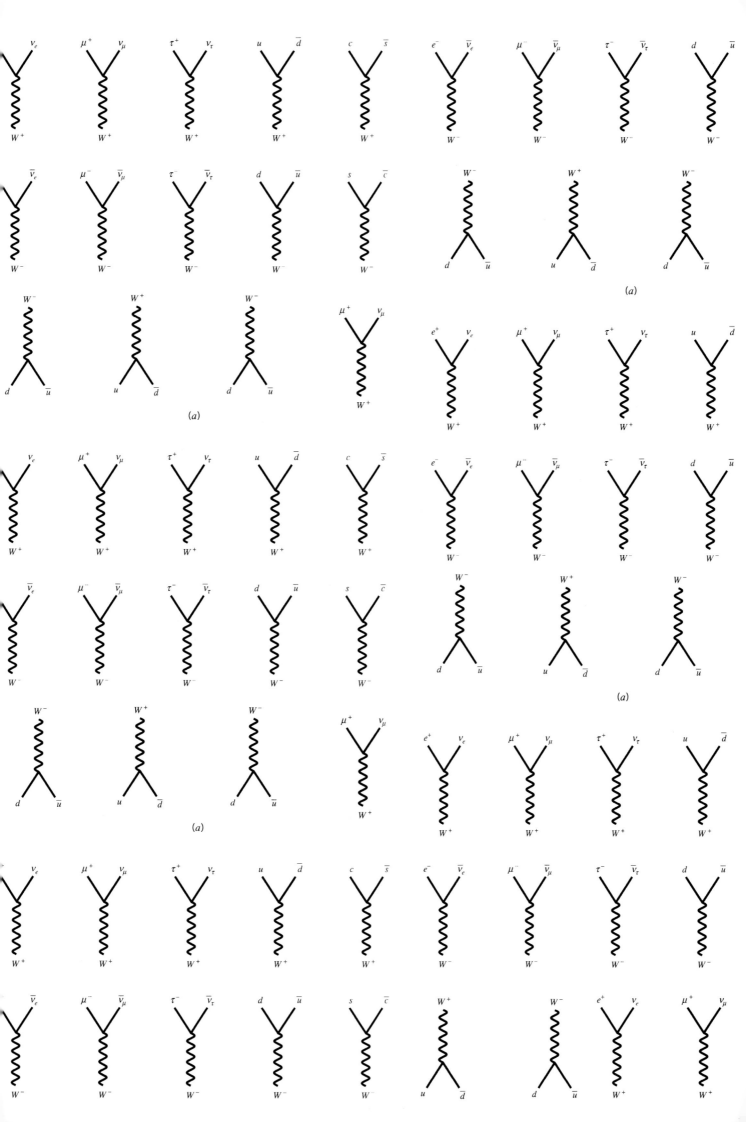

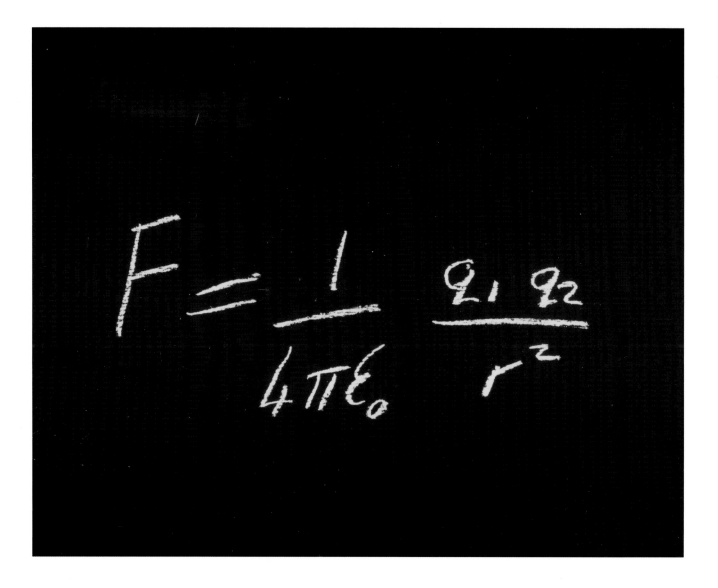

Attraction: Coulomb's Law

Classical attraction between two bodies increases as the distance between them diminishes.

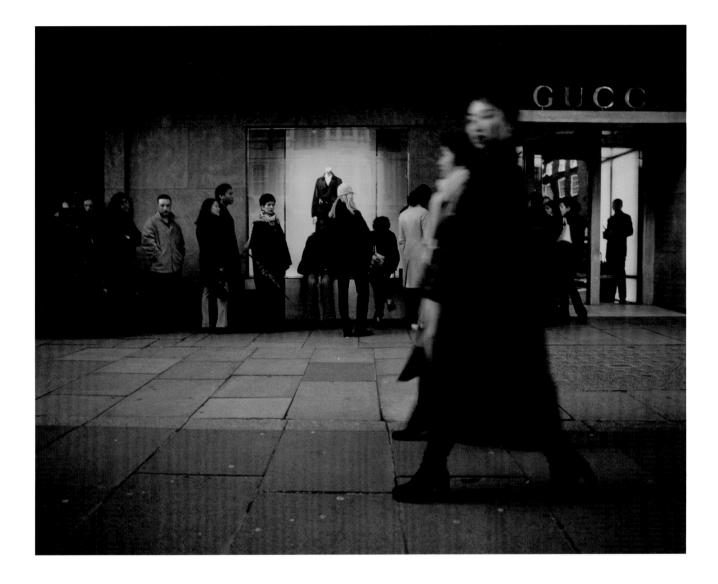

1

~~████████~~ Systems

"The very first of all, CHAOS came into being." Hesiod, ~~████████~~

1.1 Prelude

Chaos is the term used to describe the ~~████████~~ behavior of what we consider to be simple, ~~████████~~. ~~████~~ behavior, when looked at casually, looks erratic and almost random—almost like the behavior of a system strongly influenced by ~~████████~~ or the complicated behavior of a system with many, many degrees of freedom, each "doing its own thing."

The type of behavior, however, that in the last 20 years has come to be called *chaotic* arises in very ~~████~~ systems (those with only a few active degrees of (freedom)), which are almost free of noise. In fact, these systems are ~~████~~ deterministic; that is, precise knowledge of the conditions of the system at one time allow us, at least in principle, to ~~████████~~ behavior of that system. The problem of understanding chaos is to reconcile these apparently conflicting notions ~~████████~~.

The key element in this understanding is the notion of ~~████~~. We can develop an intuitive idea of nonlinearity by characterizing the behavior of a system in terms of stimulus and response: If we give the system a ~~████~~ and observe a ~~████████~~, then we can ask what happens if we ~~████~~ system twice as hard. If the response is ~~████~~, then the system's behavior is said to be linear (at least for the range of ~~████████~~). If the response is not ~~████~~ (it might be larger or smaller), then we say the system's behavior is ~~████~~. In an acoustic system such as a record, tape, or compact disc player, ~~████████~~. In the next section, we will develop a more ~~████████~~. The study of ~~████~~ behavior is called *nonlinear dynamics*.

Why have scientists, engineers, and mathematicians become intrigued by ~~████~~? The answer to that question has two parts: (1) The study of chaos has provided new ~~████████~~ us to categorize and understand complex behavior that had confounded previous theories; (2) chaotic behavior seems to be ~~████~~—it shows up in mechanical oscillators, electrical circuits, lasers, ~~████████~~, chemical reactions, nerve cells, heated fluids, ~~████████~~. Even more importantly, this chaotic behavior shows dramatic qualitative and quantitative universal features. These universal features are independent of the details of the particular system. This universality means that what we learn about chaotic behavior by studying, ~~████████~~

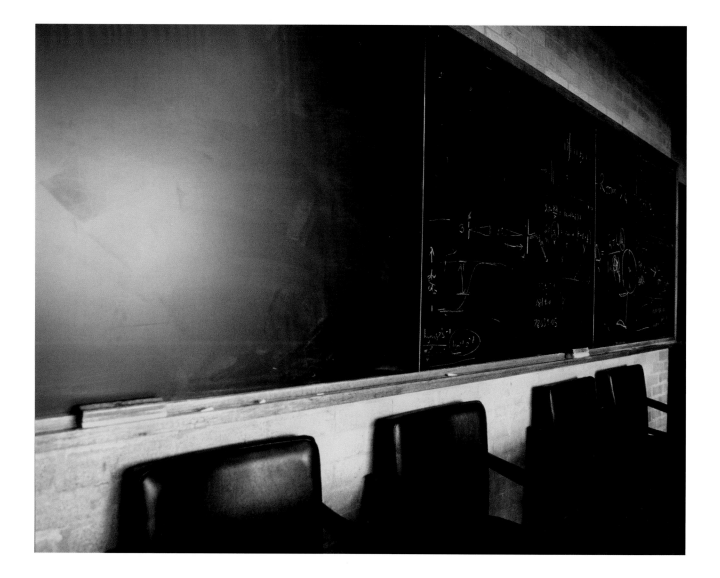

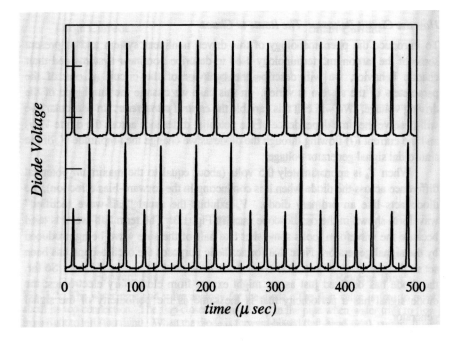

Model No. PA-____
CFG. Pop Top
Serial No. 30-TP30091A
Bias Volt. 2000 V Pos.
PATENT NO. 4,851,684
MADE IN U.S.A.

ORTEC

PROPERTY OF
UNIVERSITY OF MANCHESTER
DEPARTMENT OF PHYSICS
03950

CAUTION

Do not attempt to remove
detector capsule from cryostat
until you are sure cryostat is at
room temperature.

Be certain detector capsule is
firmly attached to cryostat
before cooling with liquid
nitrogen.

◀ INSTALL ◀ INSTALL ◀ INSTALL ◀ INSTALL
REMOVE ▷ REMOVE ▷ REMOVE ▷ REMOVE ▷

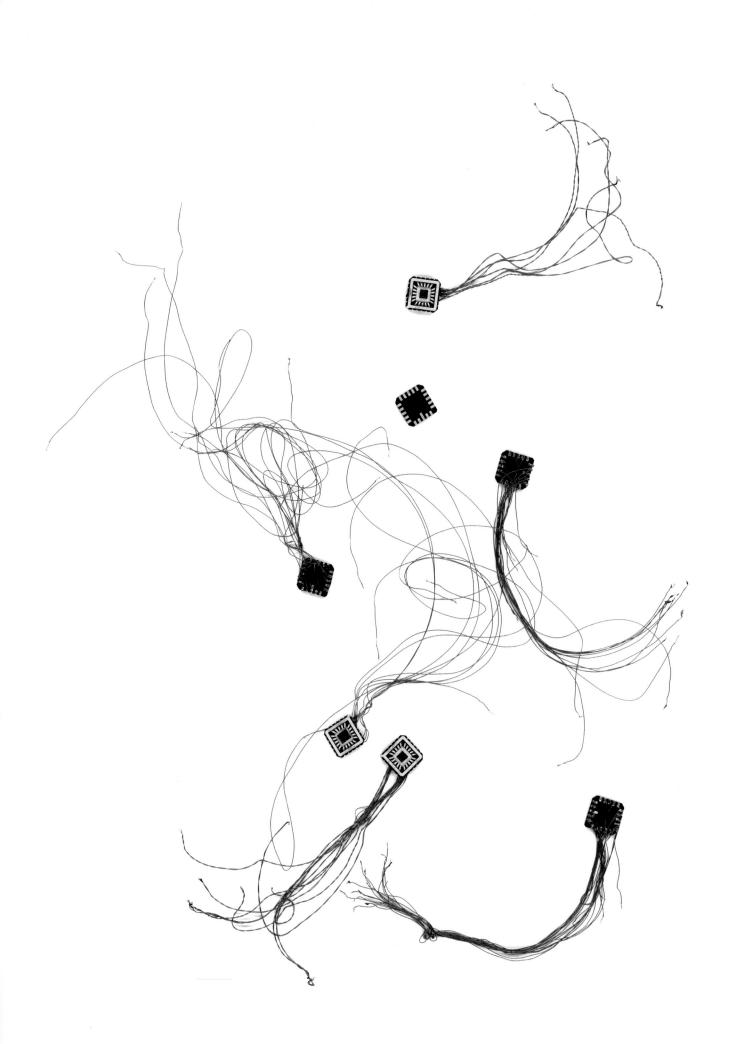

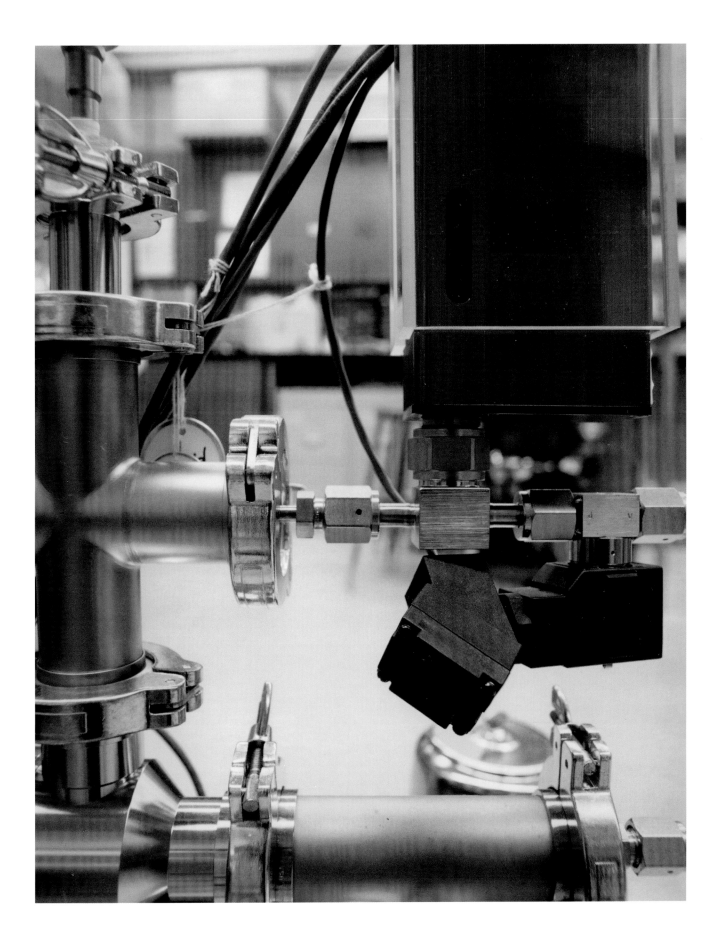

ne phase

$$v_p = \frac{\omega}{n_r \frac{\omega}{c}}$$

Real path

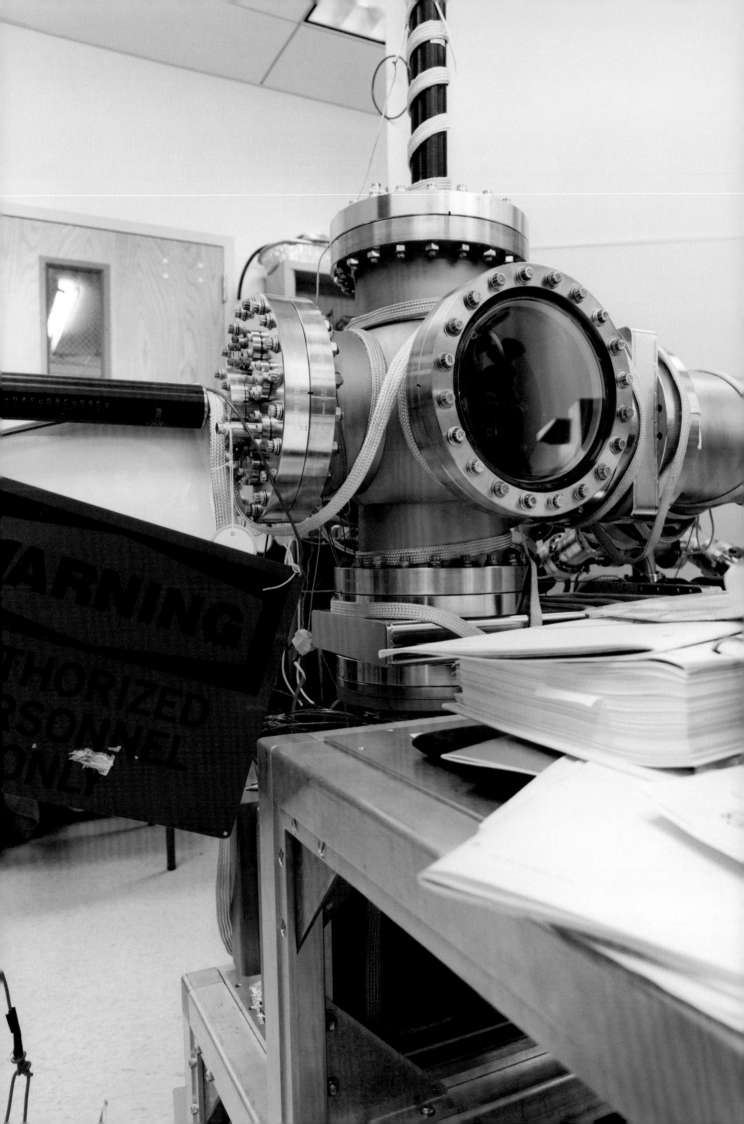

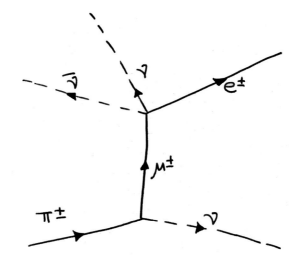

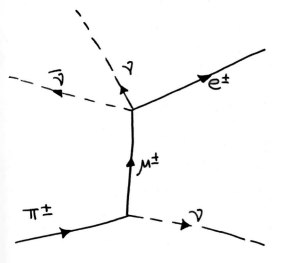

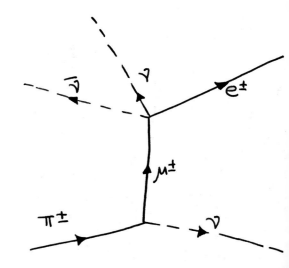

$$t_{FF} = \left[\frac{3\pi}{32 G \rho} \right]^{\frac{1}{2}}$$

Stellar Contraction

The release of gravitational energy can cause the rapid collapse of a stellar body.

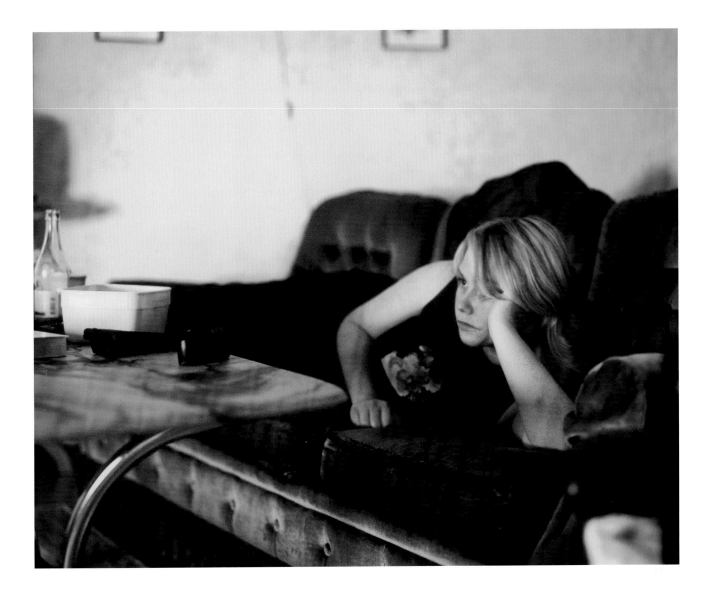

$\underline{R_3 = 2k\Omega}$ $5 \times 10^{-4} \Omega^{-1}$

θ_n	θ_{n+1}	(θ_n/θ_{n+1})
3.4	1.5	2.27
5.1	2.2	2.32
2.7	1.2	2.25
4.1	1.7	2.41
2.8	1.2	2.33
4.1	1.7	2.41
3.0	1.3	2.31
4.4	1.9	2.32

$\sigma(\theta_n/\theta_{n+1}) = \frac{1}{\sqrt{7}}\{0.0234\}^{1/2}$

$= 0.05782$

$\sigma_\lambda = 0.03$

Average $(\theta_n/\theta_{n+1}) = 2.33$ $\Rightarrow \underline{\lambda = 0.84}$ for $R_3 = 2k$

$\underline{R_3 = 1k\Omega}$ $1 \times 10^{-3} \Omega^{-1}$

θ_n	θ_{n+1}	(θ_n/θ_{n+1})
1.6	0.4	4.00
1.9	0.4	4.75
4.1	0.8	5.13
1.7	0.4	4.25
3.6	0.7	5.14
1.4	0.3	4.67
3.1	0.6	5.17
1.9	0.4	4.75

$\sigma(\theta_n/\theta_{n+1}) = \frac{1}{\sqrt{7}}\{1.2894\}^{1/2}$

$= 0.42919$

$\sigma_\lambda = 0.09$

Average $(\theta_n/\theta_{n+1}) = 4.73$ $\underline{\lambda = 1.55}$ for $R_3 = 1k\Omega$

Error bar on λ.

$\frac{d\lambda}{d(1/R)}) = 1.3397 \times 10^3$

Gradient $= 1339.76$

$= 1.3397 \times 10^3 \Omega$

:When $\lambda = 2\pi$

error Grad $= 1380 \Omega$

$R = \frac{1.3397 \times 10^3}{2\pi}$

\Rightarrow When $\lambda = 2\pi$

$= \underline{213\Omega}$

$R = \frac{1380}{2\pi} = 219\Omega$

$\sigma_R = 6\Omega$ $\Rightarrow \underline{R = (213 \pm 6)\Omega}$

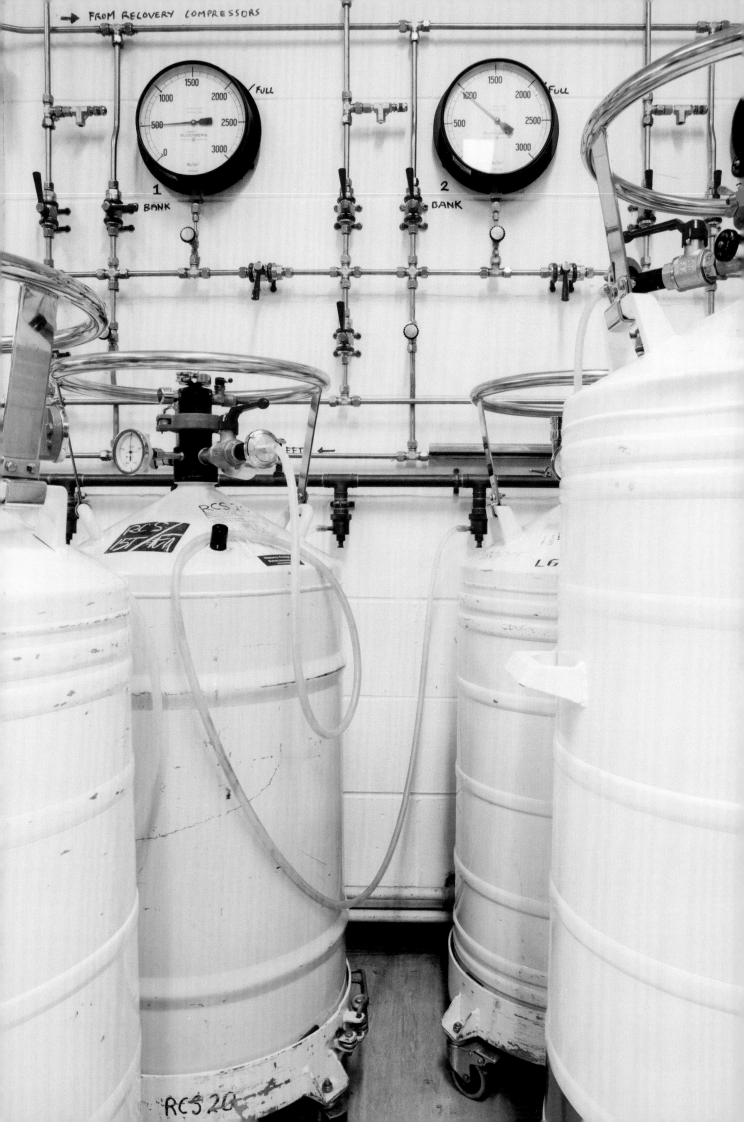

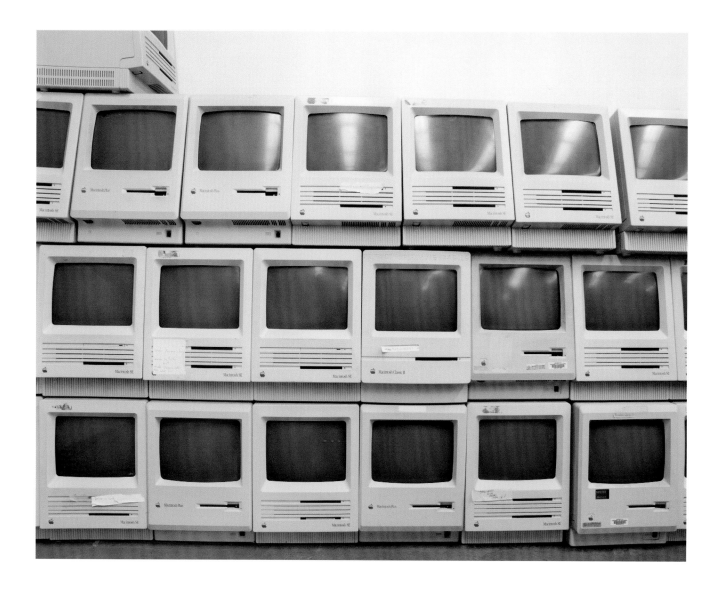

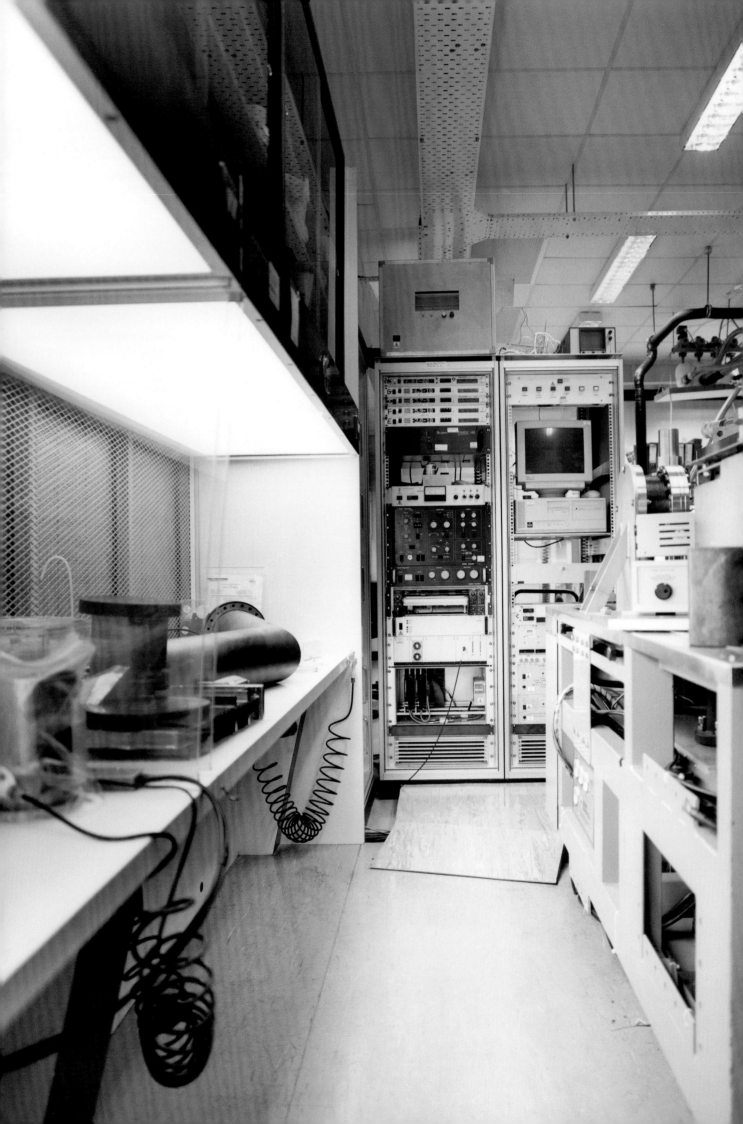

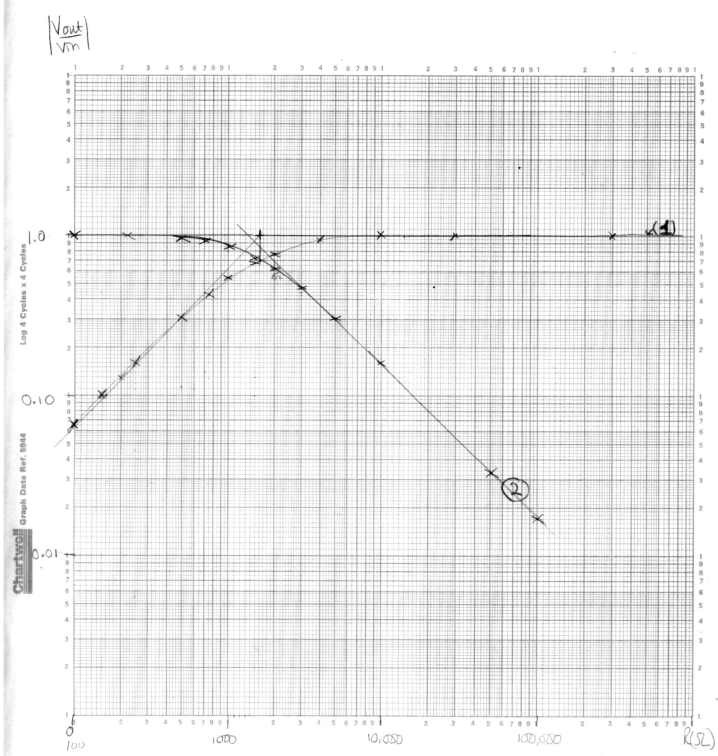

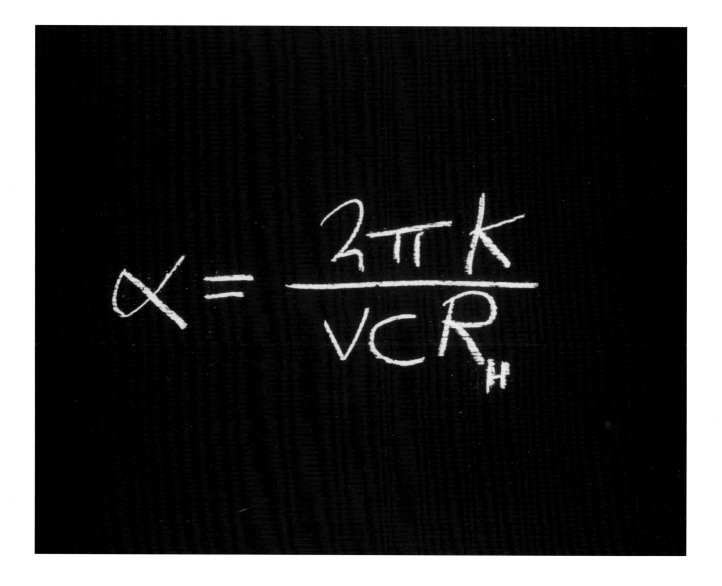

Quantum Hall Effect

The electromagnetic coupling constant diminishes as the resistance displayed increases.

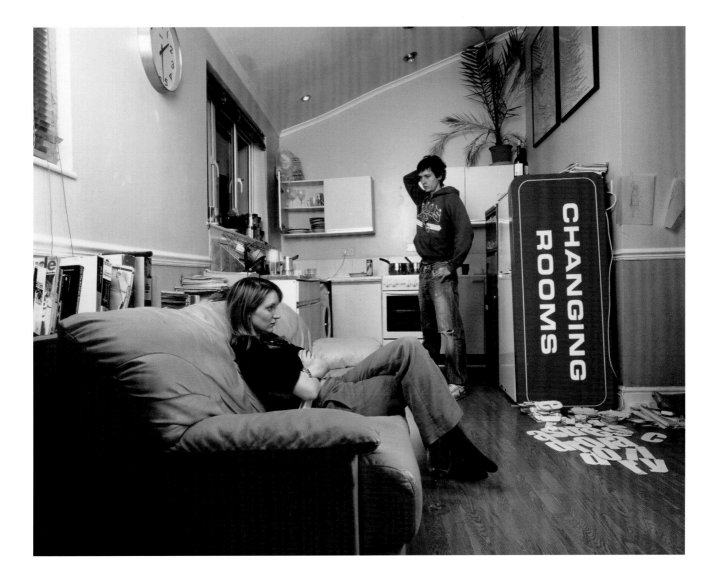

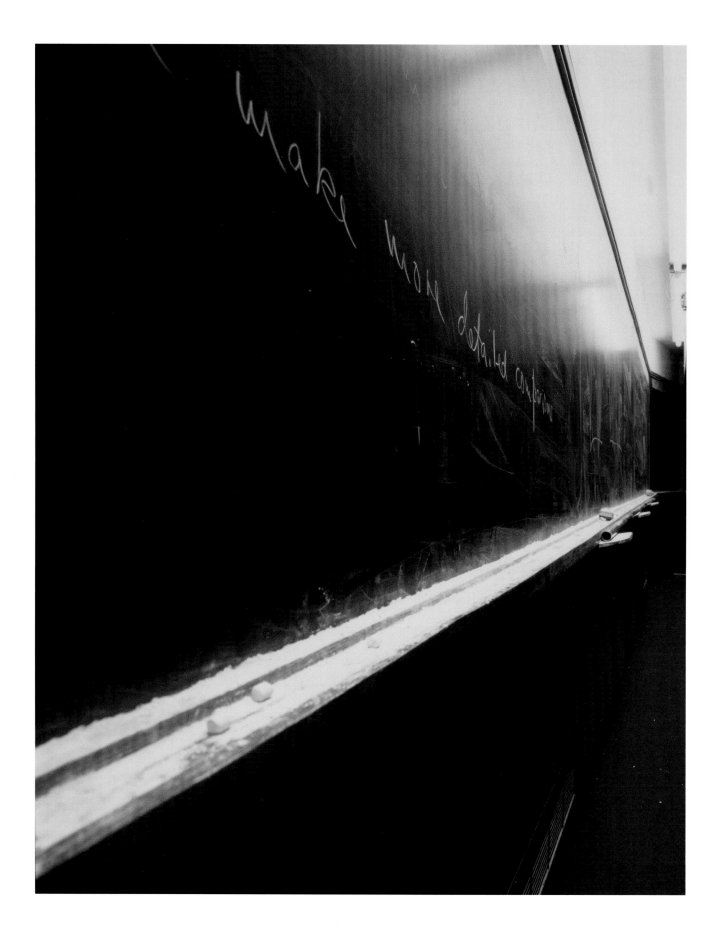

Periodic Table of the Quarks

	Group I	Group II	Group III
	Up +2/3 R,G,B 1/2 u ~5 MeV	Charm +2/3 R,G,B 1/2 c ~1500 MeV	
	Down −1/3 R,G,B 1/2 d ~10 MeV	Strange −1/3 R,G,B 1/2 s ~150 MeV	Bottom −1/3 R,G,B 1/2 b ~5000 MeV

Name charge (e)
color
spin

symbol

mass energy

Periodic Table of the Leptons

	Group I	Group II	Group III
	Electron −1 1/2 e 0.5110 MeV	Muon −1 1/2 μ 105.7 MeV	Tau −1 1/2 τ 1777 MeV
	Electron 0 Neutrino 1/2 ν_e < 7 eV	Muon 0 Neutrino 1/2 ν_μ < 0.27 MeV	Tau 0 Neutrino 1/2 ν_τ < 33 MeV

Name charge (e)
spin

symbol

mass energy

Fundamental Bosons

Strong	Electromagnetic	Weak	Gravity
gluon color 1 g 1 < 10 MeV	photon charge 1 γ 1/137 < 3 x 10^{-27} eV	IVB weak charge 1 W,Z^0 10^{-6} 80 GeV, 91.2 GeV	energy 10^{-39}

Force

Name source
spin

symbol coupling
strength
at 1 Gev

mass energy

The general belief among quantum mechanicians is that the predictions of quantum mechanics ought to agree with the predictions of classical mechanics in an appropriate limit. This *Correspondence Principle* requires this agreement either for large values of the action or in the limit $h \to 0$. If quantum mechanics, therefore, does not describe chaotic behavior at all, it is hard to see how it would in the classical limit. Either quantum mechanics imitates chaotic behavior in some way yet to be fully understood, or, if quantum mechanics does not include such behavior, then quantum mechanics must be wrong. If such a heretical conclusion is correct, then perhaps finding out what is "wrong" with quantum mechanics will lead us on to a new and perhaps more fundamental theory that will encompass the successes of quantum mechanics, but would also include the possibility of chaos. Alternatively, quantum mechanics might be correct and what we have been calling chaos is actually an elaborate charade perpetrated by Nature. Before we come to such radical conclusions, we need to explore more fully what quantum mechanics does tell us about systems whose behavior is chaotic.

There is another reason to be concerned about chaotic behavior in quantum systems. An important extension of simple quantum mechanics is the description of systems with large numbers of particles, so-called quantum statistical mechanics. In quantum statistical mechanics, we have an added layer of statistics or randomness, above that contributed by the inherent probability distributions of quantum mechanics. A fundamental question arises. Can quantum mechanics itself account for this added randomness or must this randomness be imposed as an ad hoc feature? The quantum analog of chaos could provide a fundamental explanation of quantum statistical mechanics (KAM85). If this explanation cannot come from within quantum mechanics itself, then we must once again conclude that quantum mechanics is incomplete in its present form.

We first give a very brief synopsis of quantum mechanics to highlight those features that are important for our discussion. We then look at various approaches that have been taken to find what happens in quantum mechanics when the corresponding classical mechanics description predicts chaotic behavior. Finally we give a brief overview of some experiments that may show quantum chaos if it exists. Readers who are not familiar with quantum mechanics may wish to skip the remainder of this section.

The literature on "quantum chaos" is vast, and it would require a book in itself to do it justice. We make no pretense of covering this rapidly developing field. The interested reader is encouraged to learn more from the excellent books by Gutzwiller [Gutzwiller, 1990] and Reichl [Reichl, 1992].

A Synopsis of Quantum Mechanics

In this section we give a brief introduction to the theory of quantum mechanics to point out those features that are important in our discussion of quantum chaos. Of necessity, we must simply state results without much justification either mathematical or physical. Fortunately, to understand the issue of quantum chaos, it is not necessary to develop the full formalism of quantum mechanics. We shall

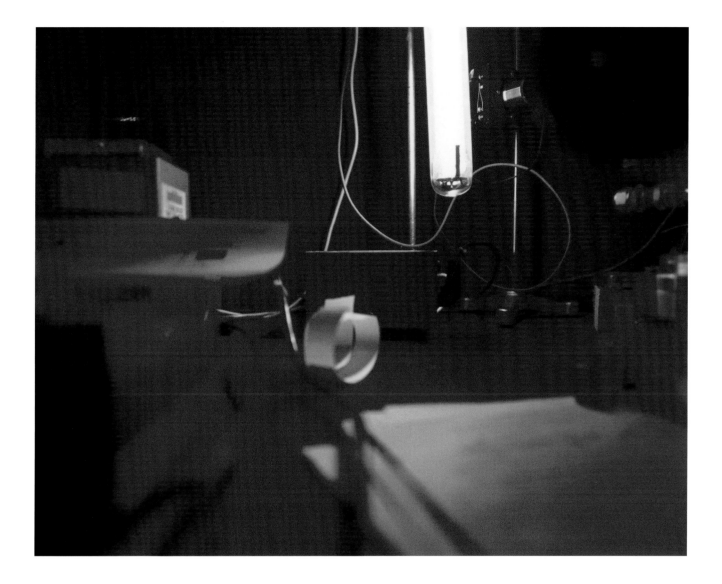

"I think that the best time to have been a theoretical physicist was around 1950-1980. I was born too late."

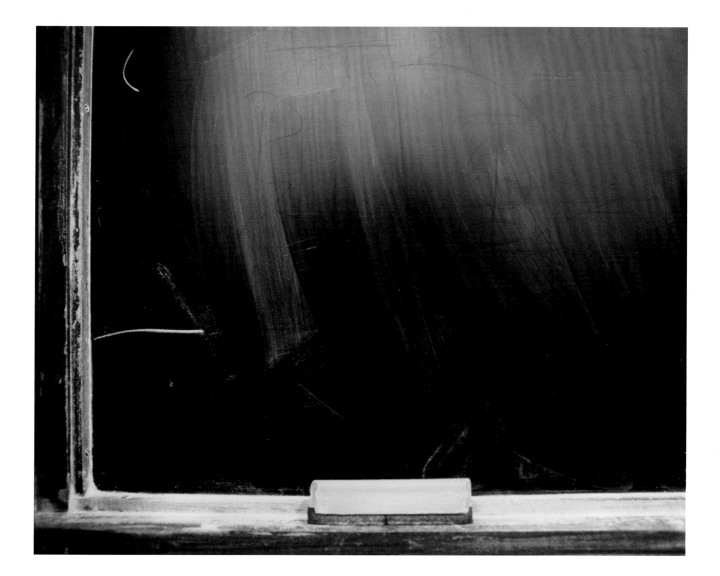

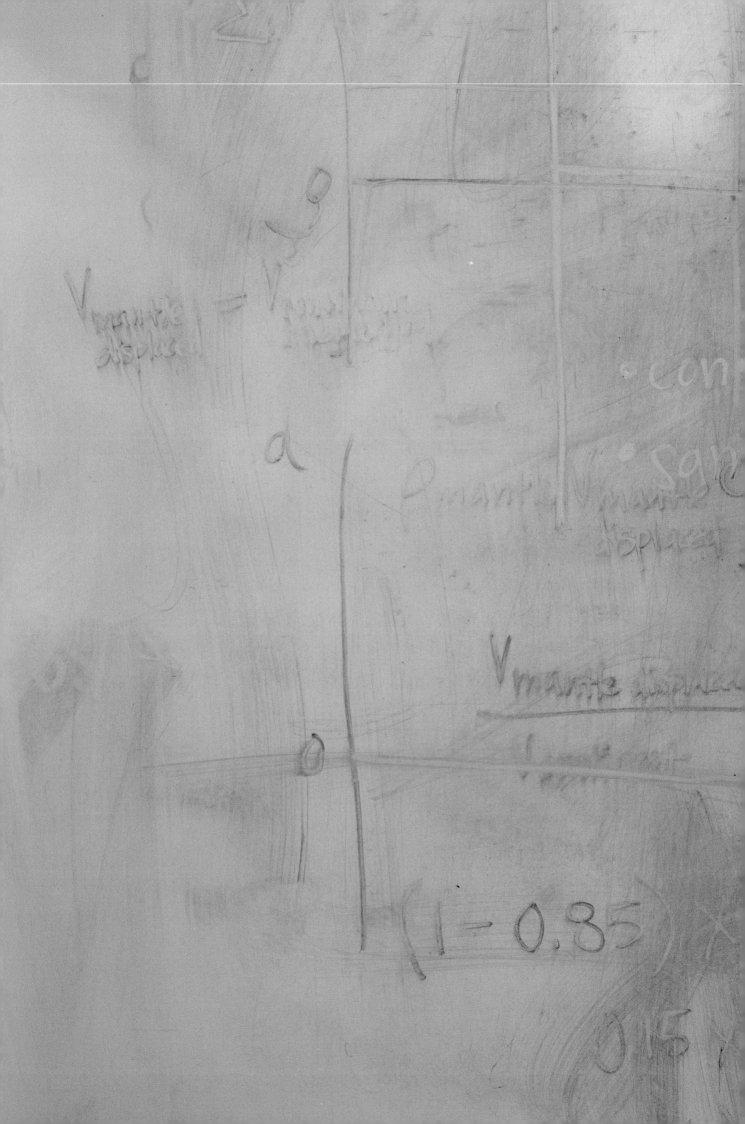

unt speed

direction continent continent g

1800k

Raising g

BHm

avg

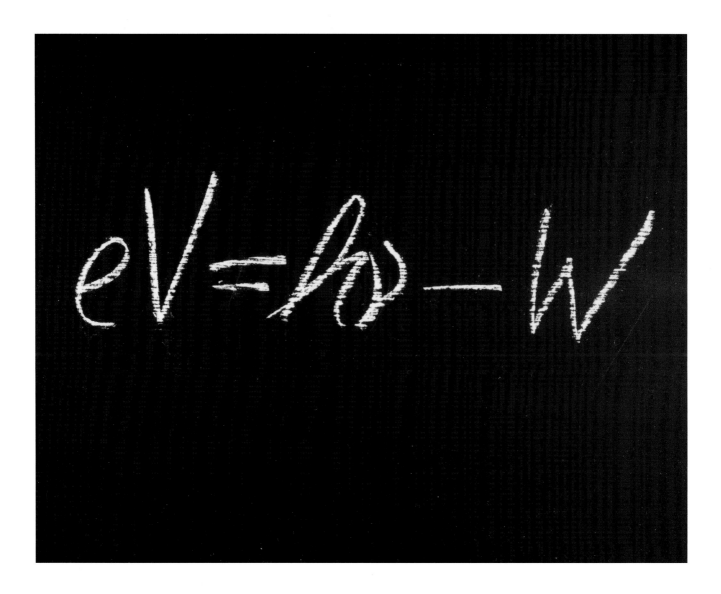

The Photoelectric effect

The energy of an illuminated electron escaping from a surface depends on the frequency of the light.

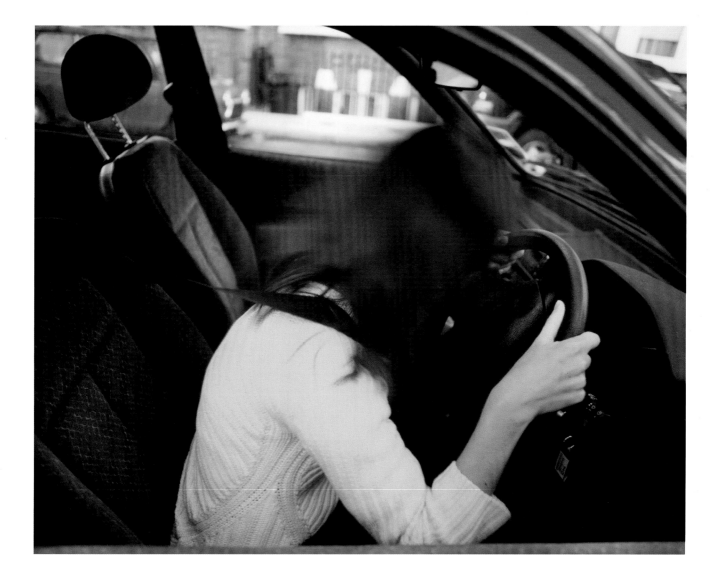

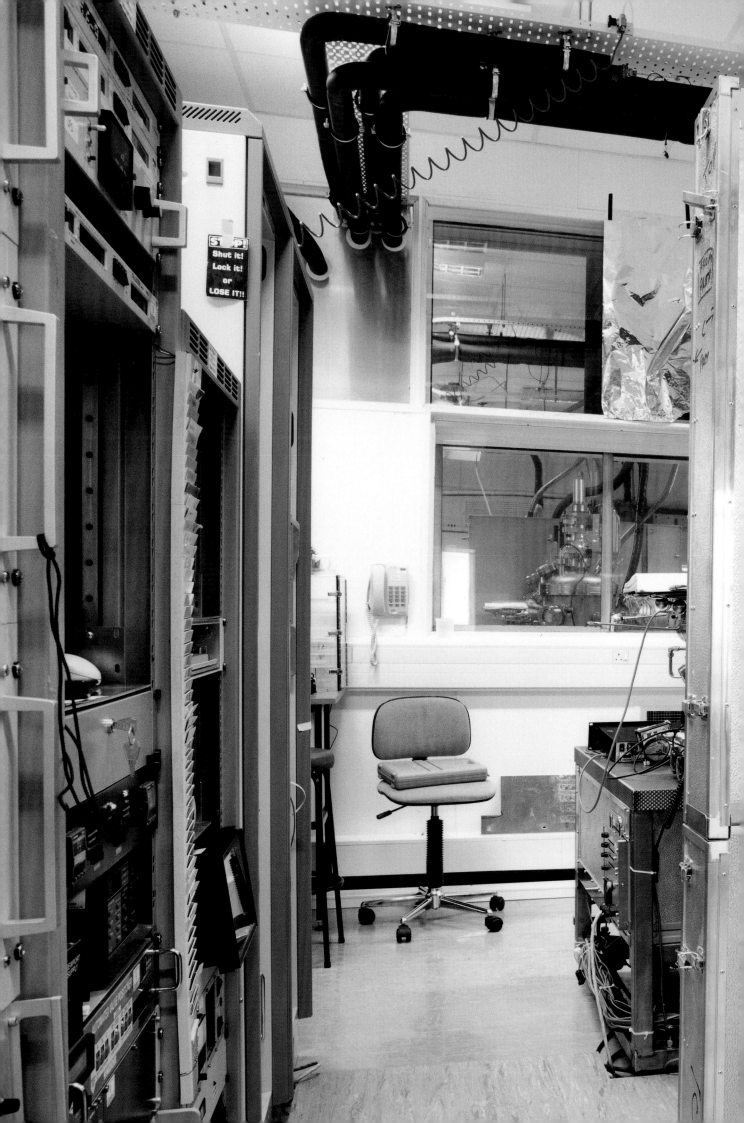

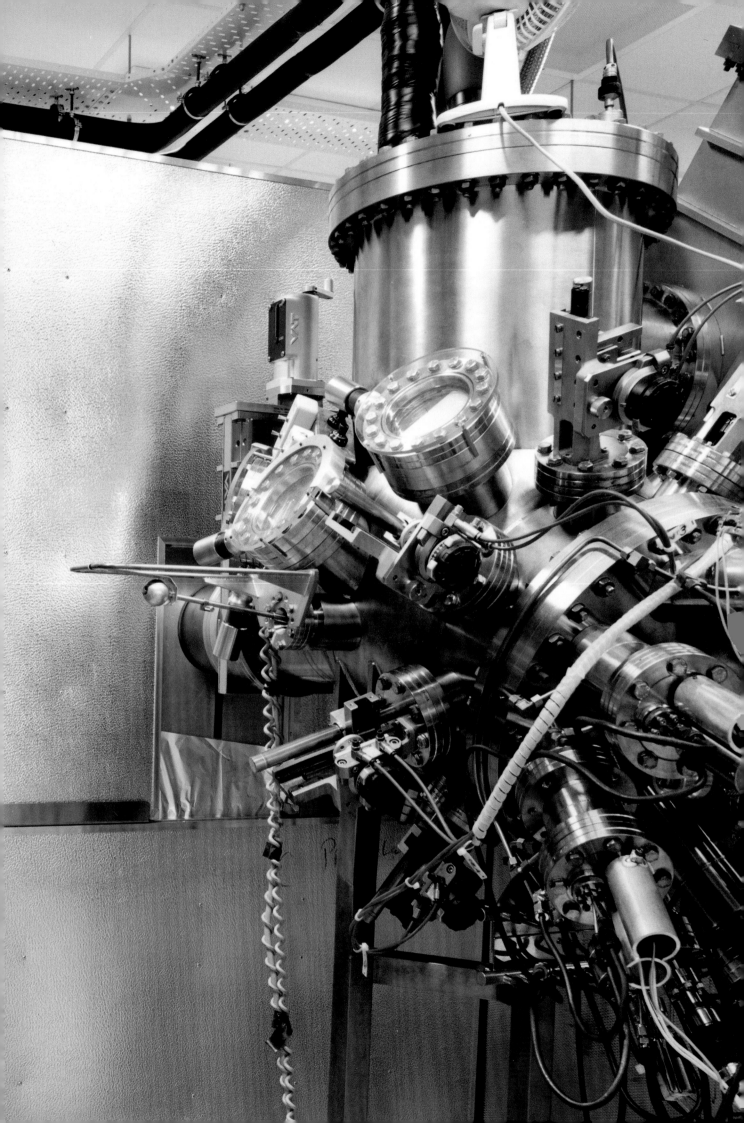

Exercise 9.5-2. Starting from the definition of Lyapunov exponent in Eq. (9.3-4), show explicitly that a linear transformation of variables $u = ax + b$ does not change the Lyapunov exponent. More challenging: what general <u>classes</u> of variable transformations lead to no change in λ ?

$$\Delta B = \frac{\mu_o}{4\pi} \frac{I \Delta \ell \sin \alpha}{r^2}$$

Magnetism: Biot-Savart's Law

The magnetic flux density experienced by an object is dependent on the angle at which it faces the current-carrying conductor.

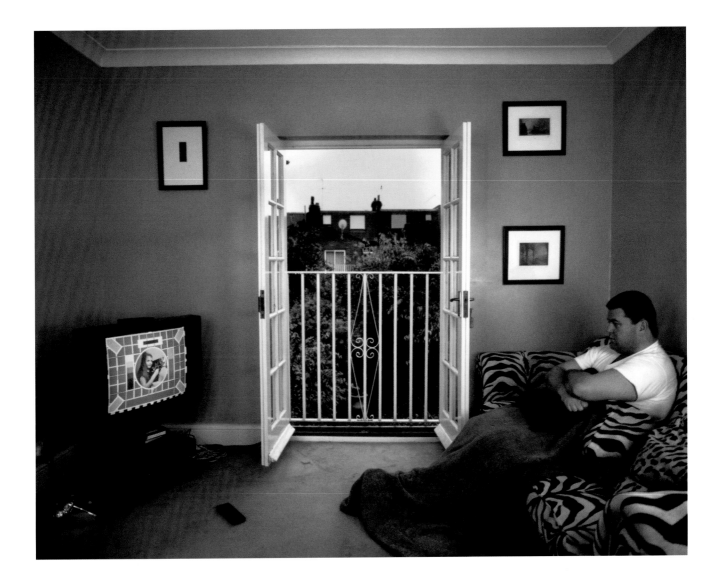

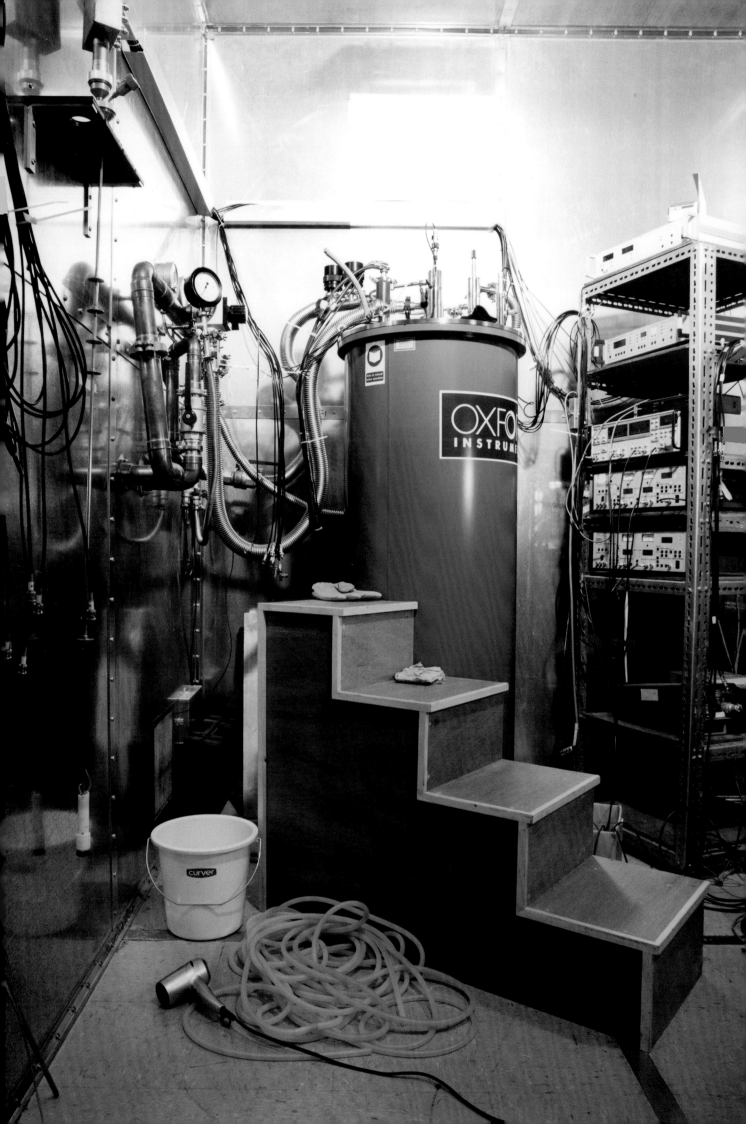

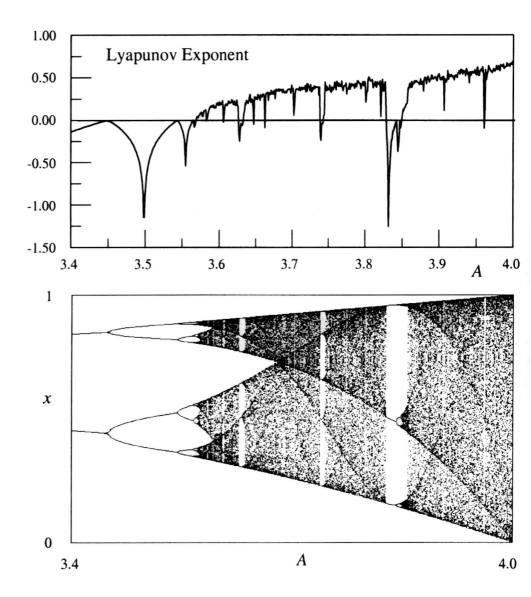

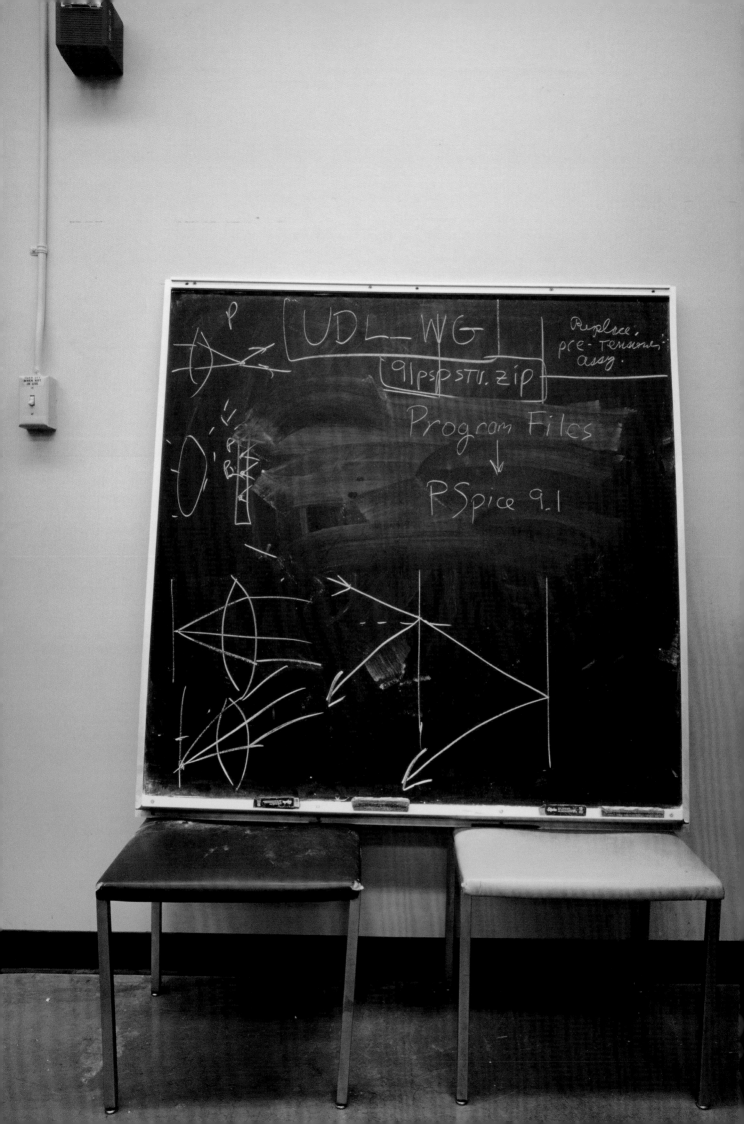

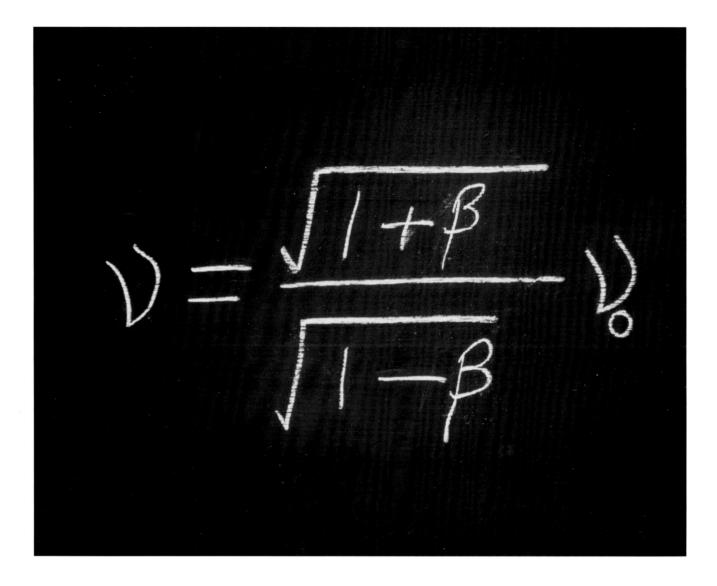

Special Relativity: Relativistic Doppler Effect

Two observers of a light-wave may experience events differently depending on their frame of reference.

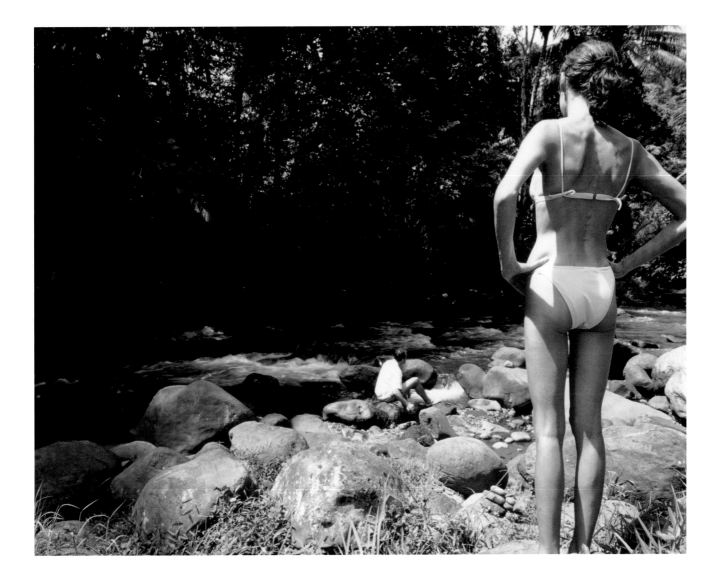

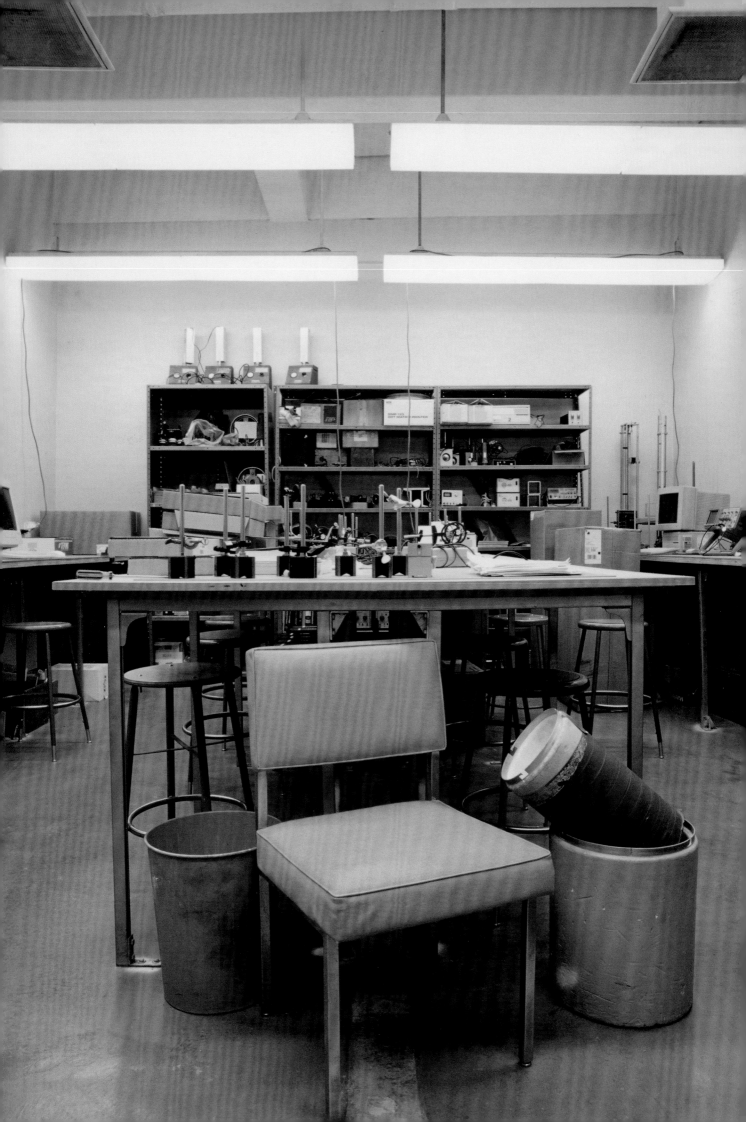

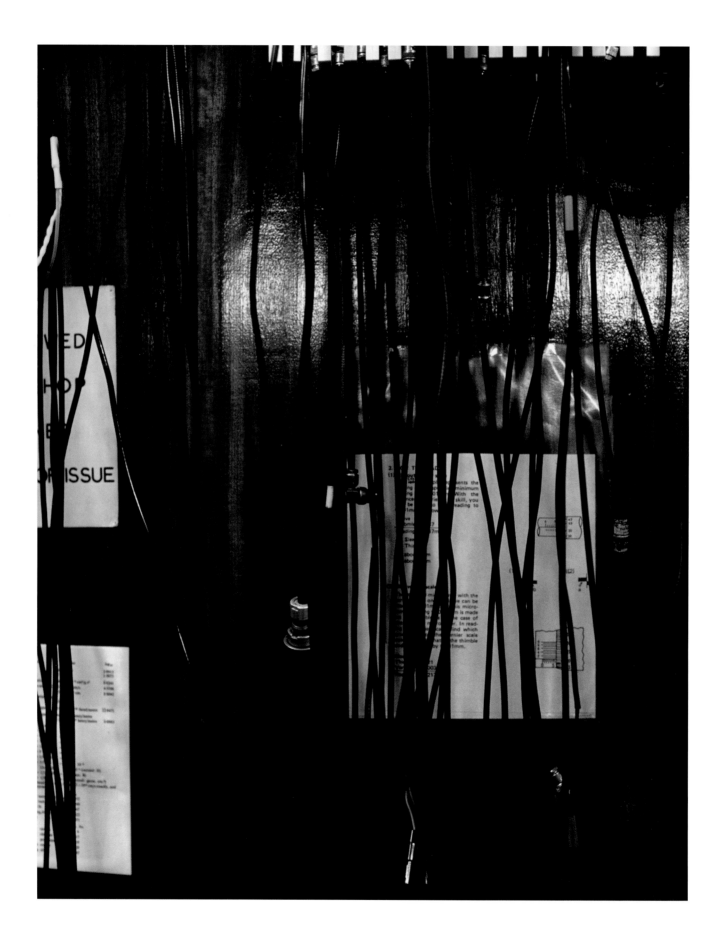

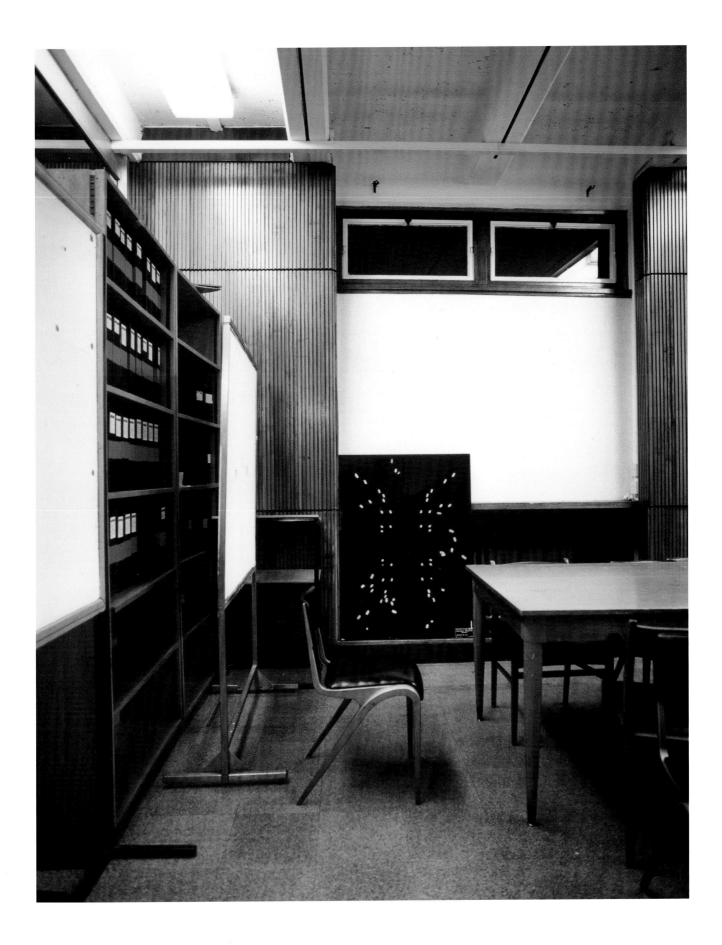

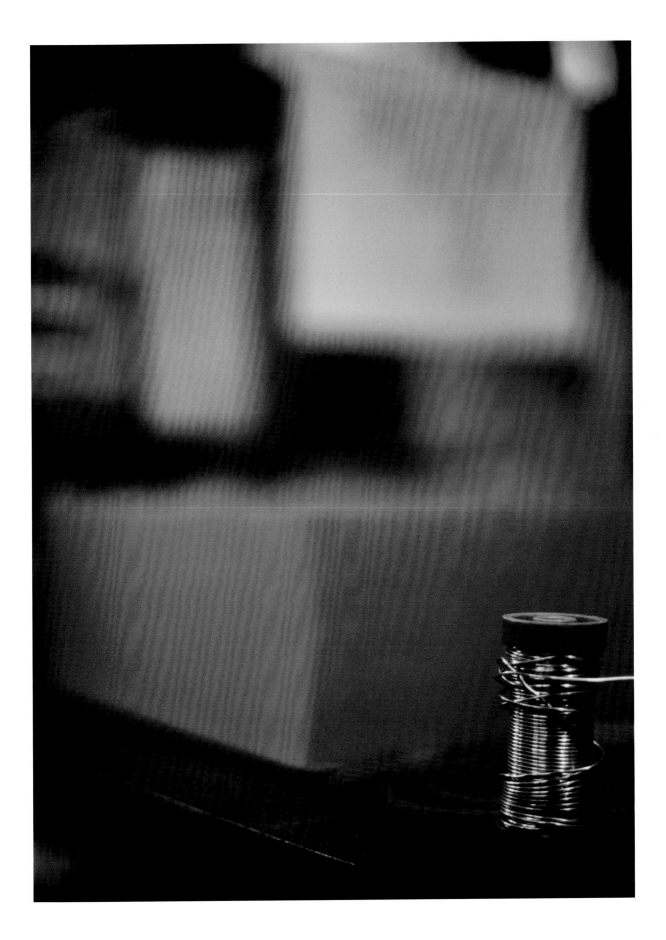

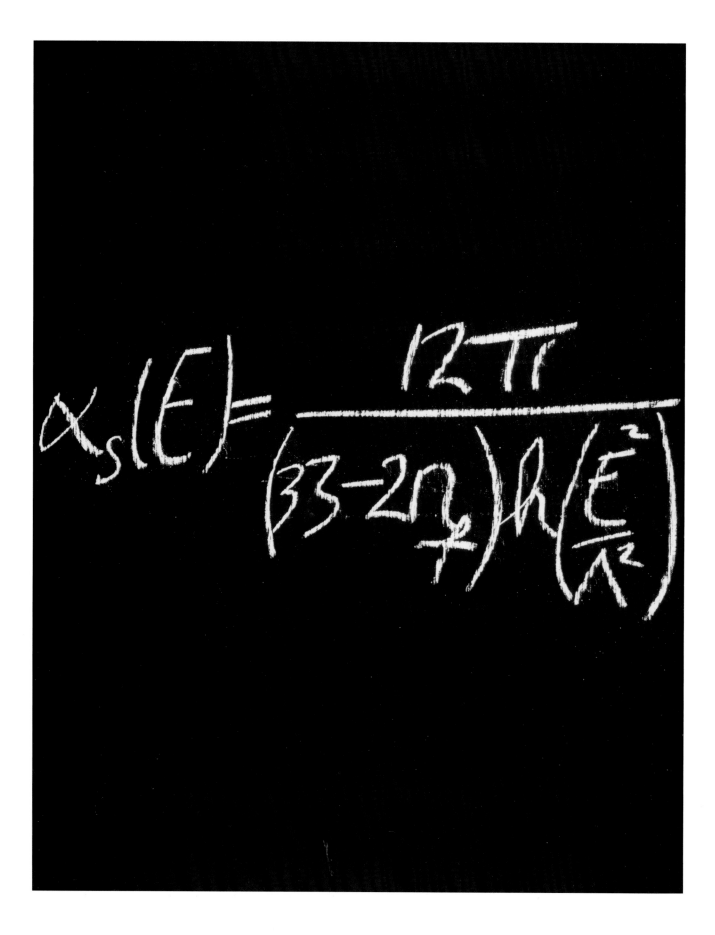

$$\alpha_s(E) = \frac{12\pi}{(33 - 2n_f)\ln\left(\frac{E^2}{\Lambda^2}\right)}$$

Strong Interaction: Quantum ChromoDynamics

The strong coupling parameter between two quarks depends on the flavours present –
the particles must maintain some distance between them in order to retain their strong attraction.

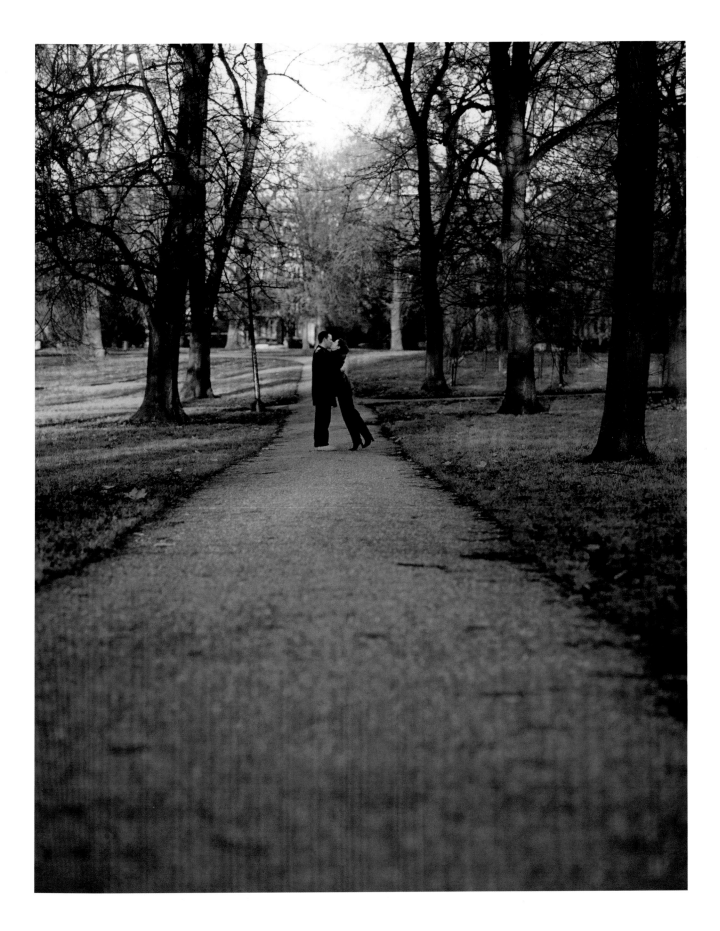